PETERBOROUGH
IN
50
BUILDINGS

LORNA TALBOTT

AMBERLEY

First published 2024

Amberley Publishing, The Hill, Stroud
Gloucestershire GL5 4EP

www.amberley-books.com

British Library Cataloguing in Publication Data.
A catalogue record for this book is available from the British Library.

ISBN 978 1 3981 1359 6 (print)
ISBN 978 1 3981 1360 2 (ebook)

Typesetting by SJmagic DESIGN SERVICES, India.
Printed in Great Britain.

Contents

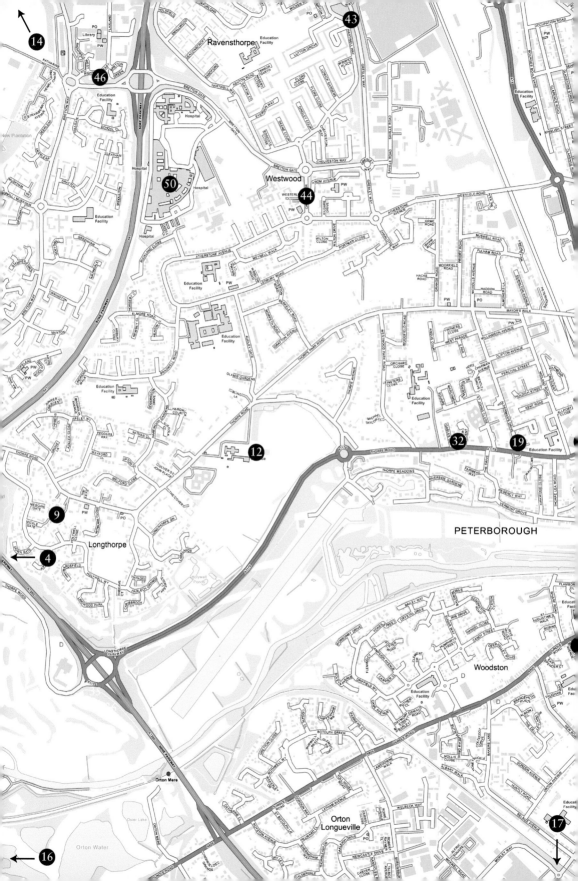

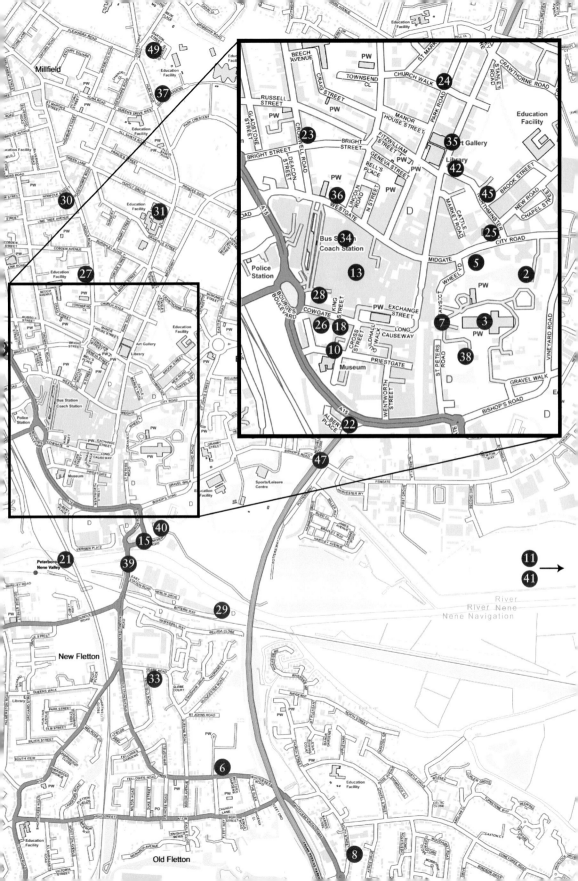

Key

Introduction

Peterborough has a history that dates back to the seventh century. This heritage is evidenced by some of the fascinating buildings and structures that have been constructed during its progression from a small monastic settlement to a modern city. Architectural highlights include the seventeenth-century Guildhall and an art deco rarity, the Lido, while the Gothic Revival design of Sir George Gilbert Scott's Peterscourt contrasts with the Early English Gothic west front of the cathedral. It is this magnificent building that is of the most historical significance for Peterborough. It has stood at its heart for over 900 years and given the city its name.

East Anglia and the Peterborough area have been inhabited for millennia. Artefacts found at Flag Fen show that Bronze Age settlers built a wooden causeway to allow access into the wetlands while the Romans considered the

Peterborough Cathedral is the largest Norman building in the country.

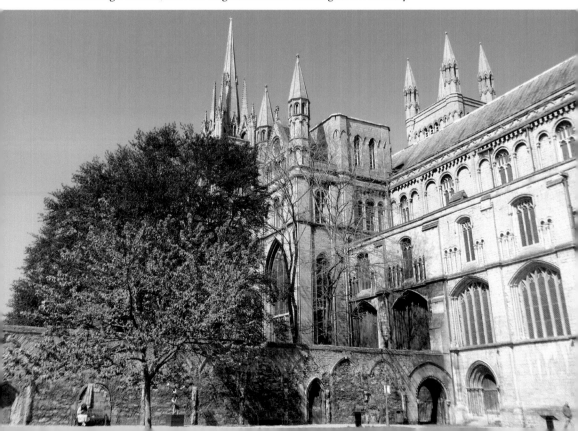

location important enough to construct a large palace at nearby Castor. In the seventh century, an abbey dedicated to St Peter was built and a settlement known as Medeshamstede, or 'homestead in the meadows', grew around it. As the danger of attacks by invading Danes increased, a defensive wall was built around the abbey and its town and the whole community was renamed St Peter's Burgh, or Peterborough.

After the Dissolution of the Monasteries saw most of the abbey destroyed, the abbey church was saved and became Peterborough Cathedral by order of Henry VIII. The abbots no longer held authority over the town and instead a fellowship of wealthy Peterborough men, the feoffees, worked together to provide amenities and alms for the benefit of residents. Peterborough became a small but thriving city and continued to prosper for the next 300 years.

The Victorian era brought the railways and increased prosperity for the city. Peterborough retains a lot of early railway heritage. It has the oldest working repair shop in the country and also a viaduct and hotel that are still used for their original purpose. A large number of properties were built in the following decades and many municipal buildings replaced.

The surrounding area has the remains of the first purpose-built prisoner-of-war camp at Norman Cross, and Romantic poet John Clare was born nearby. There is also an inn that was built as the Fens were being drained in the seventeenth

Remains from Peterborough Abbey can be seen in the city.

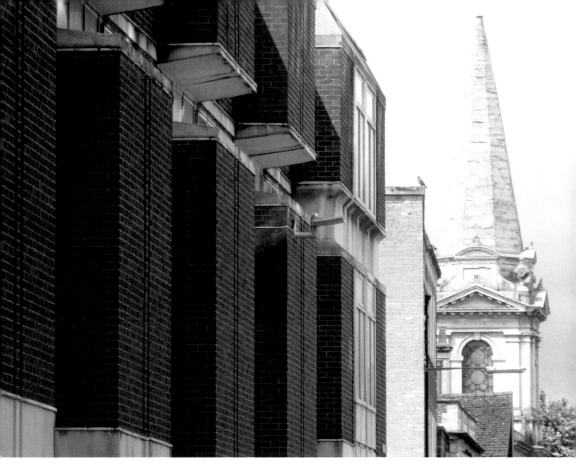

Peterborough is a mixture of ancient and modern architecture.

century. In the late twentieth century, Peterborough was developed as part of the New Towns Act and the Cambridgeshire city that was once the smallest in England trebled its population in just fifty years. Peterborough is now an Environment City, and a green and thriving urban area where sustainability and healthy living are promoted and impacts on the environment are minimised.

This glance at fifty pieces of historical architecture reveals the long history and changing circumstances of the city. Whether they are ancient or modern, industrial or residential, grand or modest, Peterborough's buildings and structures are fascinating and invite further exploration.

The 50 Buildings

1. St Augustine's Church, Woodston (c. 970)

The village of Woodston was listed as having a church dedicated to St Augustine of Canterbury in the Domesday Book. A thousand years later, St Augustine's still stands on the same spot. There have been many alterations over the years, but the church still includes part of the original Saxon building and has a Grade I listing.

The west wall of the tower contains a tiny window that is set into a deeply recessed stone surround. This was part of the first Saxon church and the size and simple shape of the window are due to the construction methods available to builders at that time. To make an aperture within a wall, a basket was woven into the required shape and the wall was built around it. When the mortar had dried, the basket was removed to leave a small chamfered window. A much more elaborate building process can be seen higher up the tower where the decorative carved bell openings are from the early Norman period.

Alterations and additions to St Augustine's continued during the medieval period, but by the nineteenth century it had fallen into such a bad state of repair that extensive building work became necessary. The west tower wall, with its Saxon window, and part of the chancel remained in a good enough condition to keep, and the church was rebuilt around these features. The interior contains the original octagonal piers, but the rest is to a typically Victorian design. The lychgate at the entrance to the churchyard was made in 1920 as a memorial to

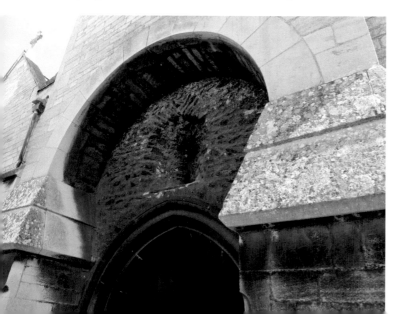

The small Saxon window in St Augustine's Church.

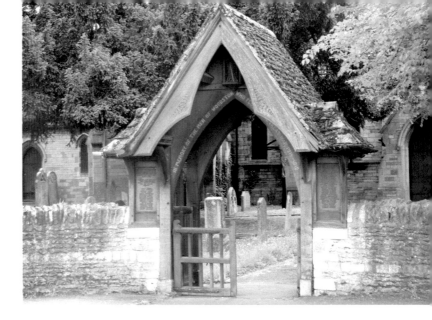

The lychgate was erected as a war memorial.

the residents of Woodston who fell in the First World War. The oak structure has carved figures inside that depict St George and the Good Shepherd.

2. Tout Hill (c. 1080)

In the eleventh century, a Norman castle was built in St Peter's Burgh to protect the abbey and town from attack by Anglo-Saxon rebels. All that remains of the structure today is a mound in the cathedral grounds. This earthwork, which has also been known as Mount Thorold after the abbot who established the castle, is now called Tout Hill.

At the time of the Norman Conquest, Peterborough, or St Peter's Burgh as it was then known, was the site of a large and powerful abbey and William the Conqueror appointed an abbot of his choice to look after this lucrative site. However, an Anglo-Saxon resistance, led by Hereward the Wake, were actively trying to drive out the Norman invaders and attempted to capture St Peter's Burgh Abbey from its Norman abbot. The abbot, Thorold, was caught and imprisoned but the subsequent disorder within the town gave him an opportunity to escape and call Norman knights to his aid. The outnumbered Anglo-Saxons fled, and the Normans secured the site once more. Abbot Thorold decided that it was essential to build a castle for protection so one was built next to the abbey. The castle consisted of a large circular motte on which a wooden keep and bailey were erected. Norman knights and fighting men were constantly stationed within the curtain wall and on alert. The political situation in the country gradually became more stable and, after the town and abbey were rebuilt in the twelfth century, the castle was no longer considered necessary and was dismantled.

Although nearly 1,000 years have passed, the remains of the motte can still be seen as a grassy bank in the Deanery gardens.

Only earthworks remain of Peterborough's castle.

3. Peterborough Cathedral (1118)

Peterborough Cathedral is one of the largest pieces of Norman architecture in the country and has been given a Grade I listing by Historic England. The history of Peterborough is inseparable from this magnificent twelfth-century building because it was on this site, in 655, that a monastery was established and the settlement that grew around it evolved to become the modern city we see today.

This Saxon settlement was called Medeshamstede and had a population that steadily grew until a Viking raid in the ninth century destroyed the monastery and drove many villagers away. However, a century later the ruined monastery was rebuilt as a large Benedictine abbey dedicated to St Peter and the community began to expand to even greater numbers than before. The new town had a defensive wall built around it to offer some protection against further raids by the Danes. Walled communities like this were called burghs and therefore the town became known as St Peter's Burgh, a name that was later contracted into Peterborough. The site was now well defended from Viking attacks, but the abbey was eventually destroyed by an accidental fire at the turn of the eleventh century. The abbey was important to the Norman administrators of the region and was immediately rebuilt bigger and more magnificent than ever. This 1118 building still survives at the core of Peterborough Cathedral where it has built upon some of the foundations from the original Saxon monastery.

The cathedral is noted for the wooden ceiling in the nave. It dates from 1220 and is the only painted ceiling of its type in Great Britain. The decorated panels depict royalty, saints and mythical beasts and, although it was overpainted in both 1745

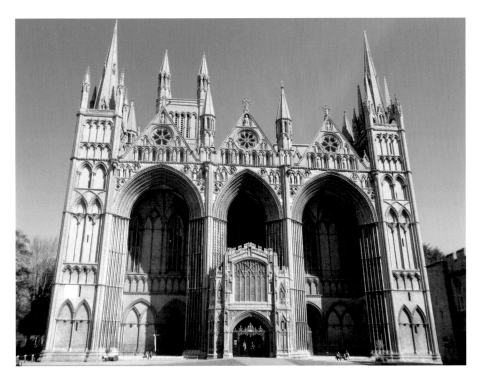

The magnificent west front of the cathedral.

and 1834, it retains its original thirteenth-century appearance. Despite surviving for 800 years, the ceiling was only designed to be a temporary measure. Later analysis has revealed that the pillars between the clerestory windows were put there to support the heavy ribs and panels of a vaulted stone roof that was never built.

Peterborough Cathedral was enlarged in the early sixteenth century when a rectangular extension was built around the Norman apse. The architecture displays exceptional perpendicular styling and is still called the New Building despite it being 500 years old. The fan-vaulted ceiling in the retrochoir is recognised as one of the best of its kind for its intricate sculpted details, which spread out from delicate columns and arches. Soon after the New Building was completed, the Dissolution of the Monasteries took away the abbey's estates and possessions. The building was saved from destruction because it contained the tomb of Katherine of Aragon. Henry VIII did not want the site to be disturbed and specified instead that the abbey should be turned into the Anglican cathedral for the region.

The cathedral was less fortunate during the English Civil War. The city of Peterborough was committed to the Royalist cause and was a stronghold for the king's men until Oliver Cromwell's Parliamentarian troops defeated them and took control of the city. The Roundheads ransacked the cathedral and did irreparable damage. They demolished the Lady Chapel and cloisters, and smashed the altar and stained-glass windows. The chapter house was also destroyed and

the cathedral's library was burnt. Precious medieval decorations and sculptures that were vandalised still bear the marks of their defacement today. The cathedral remained in this condition until the nineteenth century when Victorian restorers began to address the damage. However, many statue niches were left empty to highlight the number of important artefacts that had been lost forever.

A major restoration of Peterborough Cathedral was undertaken between 1882 and 1886 when its central tower was completely rebuilt to stabilise the building.

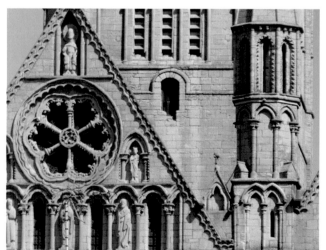

Above: Norman details can be seen all around the building.

Left: Peterborough Abbey became a cathedral in the sixteenth century.

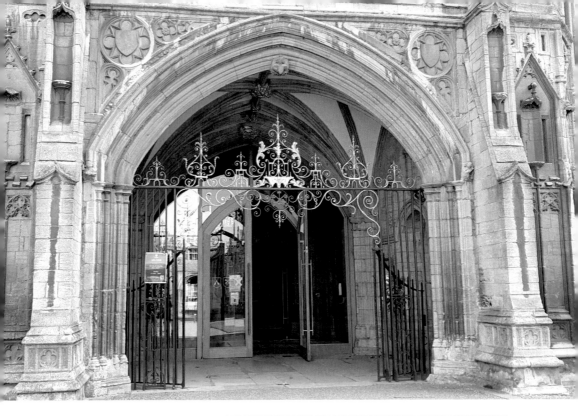

Above: Medieval statue recesses remain empty by the modern doorway.

Right: William Morris designed some of the nineteenth-century stained-glass windows.

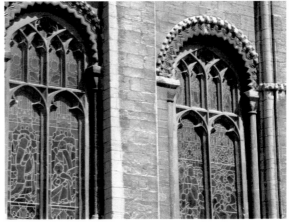

The interior also had a full redecoration. The cathedra, choir stalls and pulpit were all replaced with new ones of hand-carved wood, and some of the windows had their missing stained glass replaced with designs by William Morris.

The cathedral is of great architectural interest and historical importance and thousands of visitors come to Peterborough every year to visit it. There are many more treasures to be seen both outside the building and within. One is the ninth-century Hedda Stone, which lies behind the altar. It is an ancient carving that shows the Viking raid that destroyed Medeshamstede Monastery. It was carved in 870 as a memorial to those who died at the hands of the Danes.

4. St Kyneburgha's Church (1124)

The ancient church of St Kyneburgha in Castor has a history that dates from Roman times. It has a Grade I listing from Historic England due to its exceptional Saxon, Norman and medieval features and is considered to be among the most archaeologically significant churches in the country.

In the third century a grand residence was built on the site where the church now stands. It was the second largest Roman building ever constructed in Great Britain and was occupied for 200 years before being deserted after the Roman authority in Britain crumbled. Archaeologists have found Christian artefacts nearby that date from the third and fourth centuries, which suggests that Romano-British Castor was an early site of Christianity. The foundations of the Roman palace can still be seen just outside the church grounds.

In 650, the derelict Roman palace was chosen as the site for a convent founded by Kyneburgha, the daughter of King Penda of Mercia, and the new structure reused any available building materials in the area. A Roman altar can still be seen within the church where it was repurposed to form the base of a Saxon cross. Kyneburgha became the first abbess, and she was venerated as a saint after her death. Her tomb became a shrine and the church still contains the eighth-century carving of an Apostle that formed part of this shrine. Ninth-century Viking raids

St Kyneburgha's Church is ancient and architecturally significant.

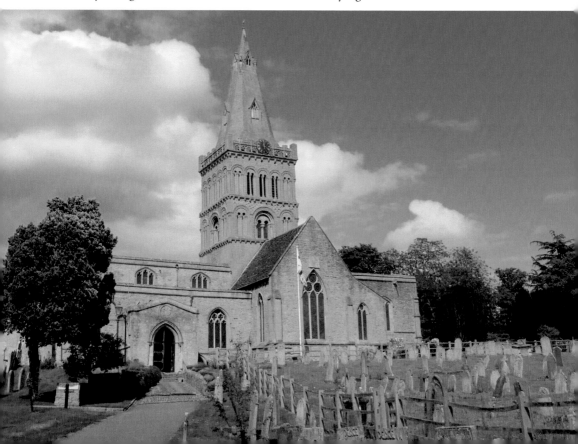

Right: The carving above the door dates from Saxon times.

Below: Exceptional Norman stonework decorates the tower.

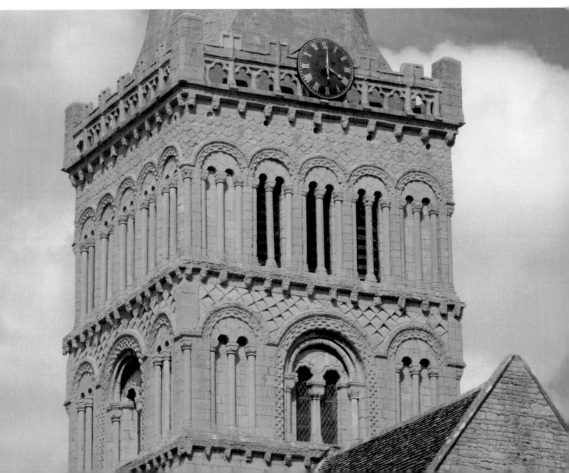

left the convent in ruins, but the Saxon church was rebuilt and uniquely dedicated St Kyneburgha in 1124. Other Saxon remains include parts of the nave and the carving of Christ in Majesty over the south porch.

The new Norman building was highly decorative and, despite later alterations, St Kyneburgha's Church still has notable Norman features. The tower is one of these. It has finely carved rows of corbel stones and the bell arches are in typical Norman style but are more intricate than is usual. Inside, the octagonal and round piers of the nave have ornamental capitals featuring plants and animals. The square Norman tower was topped with a spire in the fourteenth century when the clerestory was added. Other outstanding medieval elements are the wall painting of St Catherine and the magnificent timber roof, which depicts brightly coloured angels with instruments. Although it has been overpainted in later years, the bright colours are true to the medieval originals because it fortunately escaped overpainting at the time of the Reformation due to its height and inaccessibility.

5. The Deanery (1138/1875)

The Deanery stands close to Peterborough Cathedral and has a Grade II listing from Historic England. This is in recognition of both its antiquity and the later Victorian restoration by Sir George Gilbert Scott.

George Gilbert Scott was a gifted and prolific Victorian architect and a leading contributor to the Gothic Revival movement. He was awarded the post of architect for Westminster Abbey in 1849 and was in charge of its restoration and refurbishment. In the nineteenth century 80 per cent of churches were restored, many by Gothic Revivalists who favoured the look of medieval churches before they were stripped of decoration during the Reformation. Retrospectively, it has been recognised that, while features that had been hidden or overpainted were recovered, others that should have been preserved were lost in the redecoration process. Gilbert Scott sympathetically restored the Deanery in Neo-Gothic style in 1875.

The property has a long history and is linked to that of Peterborough Cathedral. It was built in 1138 as accommodation for the prior, and some of this original stonework can be seen in the interior of the kitchen. The building became lodgings for the dean when Peterborough Abbey became a cathedral, although it was temporarily given over to the military commander of Peterborough during the English Commonwealth.

The thirteenth-century great hall still forms the east wing of the restored property. Gilbert Scott's Neo-Gothic design has created a building where features that were built centuries apart blend into each other. This can be seen in the window surrounds, which are a mixture of both thirteenth-century arches and square nineteenth-century stonework. The Deanery is set in mature gardens of which the earthworks of Tout Hill form a part. The building is now in private ownership after it was sold in 2017 to raise funds for the cathedral.

Above: The Deanery is now a private residence.

Right: Sir George Gilbert Scott designed the Deanery's Gothic Revival restoration.

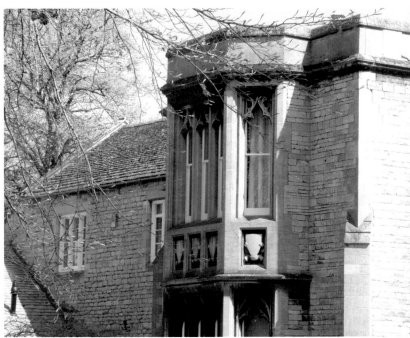

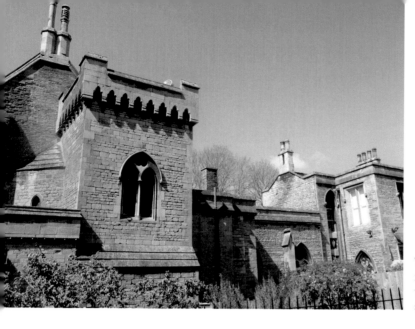

Twelfth- and nineteenth-century windows both feature stone mullions.

6. St Margaret's Church, Fletton (1150)

St Margaret's Church has been given a Grade I listing by Historic England. The church that stands in Fletton today was built in the twelfth century, although parts of the stone foundations are from an earlier Saxon building.

St Margaret's Church has fine Norman features dating from around 1150. These include the lower part of the tower and the arches in the nave, which have decorative capitals. A narrow window and the stairs to the rood loft are also

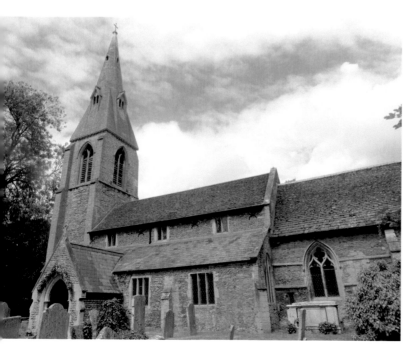

St Margaret's displays architectural styles from the last thousand years.

One of two Saxon crosses by the church porch.

Norman, but these have both been blocked in later years. The clerestory was added around 1300, although the rectangular windows were a Puritan alteration from the seventeenth century. A spire was added to the square tower in the fourteenth century but it was later struck by lightning and the one seen today dates from 1917.

There was a major restoration of St Margaret's Church in 1872. The fourteenth-century south porch was replaced as it had fallen in disrepair and the north aisle was widened. Inside, the Victorian restorers removed a tower gallery and replaced much of the woodwork. Some original interior decoration remains, however. Carvings set into the chancel wall have been authenticated as dating from the ninth century. They each depict the figure of a saint and would have originally had small pieces of quartz inlaid to give a jewelled appearance. They are believed to be altar icons from the first Saxon church and were possibly brought from the ruined monastery at Medeshamstede. The carved column of a stone cross in the churchyard is also Saxon, but has been reset on a seventeenth-century base.

7. The Great Gate (1174)

The Great Gate is the main route from Peterborough city centre into its picturesque cathedral grounds. The late Norman doorway has served this same purpose of providing a link between the town and the church since it was built into the outer

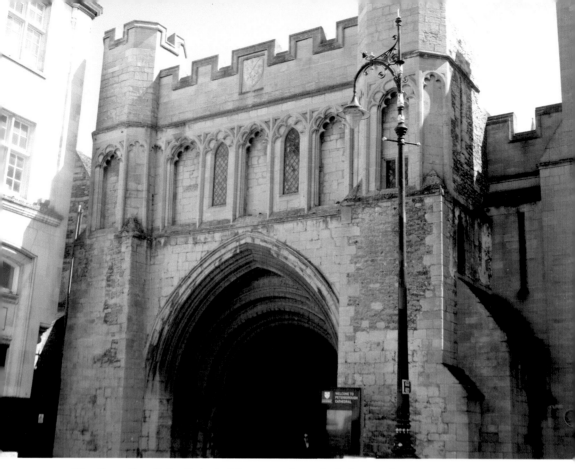

The Great Gate links Cathedral Square to the cathedral grounds.

walls of St Peter's Burgh Abbey in the twelfth century. At that time the abbot was responsible for local government and this was the place where the townspeople would raise issues and, from a window in the locked timber door of the Great Gate, both justice and charity were dispensed. There was an almshouse to the right of the gate and a jail to the left, and most problems were dealt with by one or the other.

The almshouse was dedicated to St Thomas the Martyr and took in the sick and needy until it was destroyed after the Dissolution of the Monasteries. The site is now occupied by a café. The entrance to the Abbot's Gaol is now behind the modern wall on the left side of the Great Gate. This twelfth-century undercroft still has original piers and stone vaulting and there is a small blocked Norman window concealing a tiny space that was traditionally known as the Condemned Cell. The jail was no longer in use by the seventeenth century, although Charles I is thought to have been imprisoned there after his arrest in the 1640s.

The Great Gate has been given a Grade I listing by Historic England. Original Norman stonework includes the roll moulding on the interior archway and the pillars with scalloped capitals, which support the rib-vaulted ceiling. A portcullis was added in the fourteenth century for extra security and the front elevation was remodelled at this time. The decorative arcade above the arch contains two

Above: The twelfth-century Abbot's Gaol is behind this wall.

Right: Inside the arch are well-preserved Norman features.

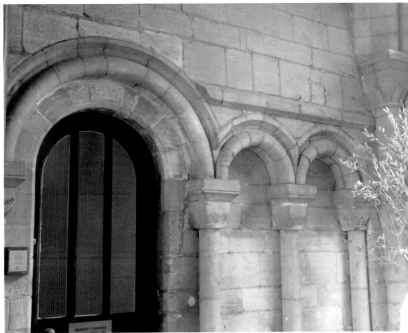

windows. These light an upper chamber that was originally a chapel dedicated to St Nicholas and was later used as a courtroom for the Abbot's Gaol. In more recent years it was used as a music room. The Great Gate was partially reconstructed in the early nineteenth century. A third storey, which was falling into disrepair, was demolished and stone turrets and crenelations erected in its place.

8. Church of St John the Baptist, Stanground (c. 1300)

The Church of St John the Baptist in Stanground has been given a Grade I listing by Historic England. Although Stanground was once a rural village, it has now become encompassed by the growth of the city of Peterborough and the church creates a picturesque scene within an area of new homes and shops.

The current stone building was built around 1300. The west tower, nave, aisles, chancel and vestry are all original and other fourteenth-century features have been reset elsewhere during later alterations. The Victorians repaired the roof and clad it in Welsh slate in 1872, and restorations were made to the south porch and east window around the same time. The stone spire, with its two tiers of skylights, was rebuilt in 1907.

Inside the church, the font has an original panelled octagonal bowl and the fourteenth-century sedilia and double piscina also survive. The Church of St John the Baptist has bench ends from the fifteenth century that feature both faces and poppy heads.

The Church of St John the Baptist in Stanground.

The Lampass Cross lay undiscovered for hundreds of years.

In the churchyard is a stone cross. It is late Saxon in origin and is complete apart from the base. It is called the Lampass Cross and originally stood at the nearby junction of the Farcet and Whittlesey roads. Over time it had fallen and was being used as a bridge over a ditch until it was recovered in 1927. It was moved to the church grounds soon afterwards, where it now stands.

9. Longthorpe Tower (1310)

Longthorpe Tower was built as an addition to the thirteenth-century manor house that stands next to it. The house was built in 1263 and the tower shortly afterwards. The interior is decorated with remarkable fourteenth-century wall murals and has been given a Grade I listing from Historic England.

Longthorpe Tower was built by Robert Thorpe around 1310 as an extension to the manor house that was his home. Although the walls are up to 7 feet thick and set with small, single-light windows, it was not designed to be defensive but instead reflected the family's wealth and status. The ground floor was used for storage while the upper storeys contained a main hall and private sleeping quarters. The main hall on the first floor has a vaulted ceiling and it is in this room that the wall paintings are to be found. These murals were also designed to display Thorpe's wealth and feature religious scenes. They decorated the walls for 200 years before being whitewashed over at the time of the Reformation. After being used by Peterborough Home Guard during the Second World War, the tower was renovated and, as 400 years of whitewash layers were removed, the murals were revealed. The owner subsequently gave the building to the nation.

Longthorpe Tower was a status symbol and not for protection.

The wall decorations are the finest domestic wall paintings in Great Britain and consist of detailed depictions of Apostles, saints and Bible scenes. It is believed that Robert Thorpe employed the best painters, who usually worked exclusively for Peterborough Abbey, to complete the decorations. Scroll work and pictures of animals and mythical beasts can also be seen, although some have lost their vibrant original colours over the centuries.

Longthorpe Tower is now a small museum and open to the public, while the adjoining thirteenth-century manor house remains in private ownership.

Fourteenth-century wall paintings can be viewed inside.

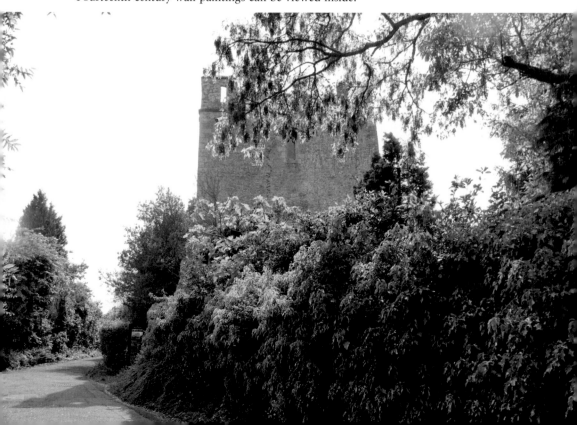

10. Yorkshire House (1510)

Yorkshire House is a Grade II listed building that stands on Priestgate. Although the ancient building has recently been converted into eight residential apartments, its character and any original features have been preserved.

Priestgate is one of the oldest streets in Peterborough and was a prestigious place to live during medieval times. Many of the houses on the street were originally owned by the abbey, but after the Dissolution of the Monasteries they were confiscated and sold. Legal documents that date from 1561 show that Yorkshire House was leased from a new owner to the Hacke family, wealthy merchants who went on to live there for many generations. Thomas Hacke became one of the first feoffees of Peterborough and it was his financial success that meant he could eventually buy the house from the landlord. However, when the family sided with the Royalists during the English Civil War, they were forced to sell it again to pay fines to Cromwell's army for their disloyalty. Yorkshire House subsequently changed hands many times and began to fall into disrepair until it was sold to property developers in the early twenty-first century.

Yorkshire House is on one of Peterborough's oldest streets.

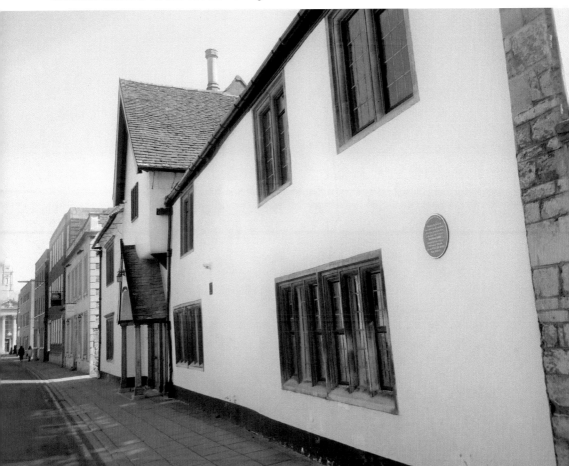

The porch and windows are Tudor originals.

The large sixteenth-century house was made when two older buildings were altered to form a single property. The jettied porch from one of these can still be seen and the stairwells of two spiral staircases, one for each house, were recovered during renovations. The timber-framed property has an L-shaped footprint and two storeys, of which the upper one is mostly under overhanging eaves. Yorkshire House has recently been rendered and many of the windows replaced, although the window over the front door is a sixteenth-century original, as are two of those on the ground floor. The chimney stacks are modern, but they have been built in a Tudor style to reflect the origin of this ancient property.

11. Dog in a Doublet (c. 1630)

The white-painted building which stands on the banks of the River Nene at Whittlesey is the former Dog in a Doublet public house. After falling into dereliction, the 400-year-old building was renovated in the twenty-first century to become an inn well known for its good food and atmosphere. However, the establishment closed finally in 2023.

The Dog in a Doublet dates from a time when the land around Peterborough consisted of waterlogged marsh instead of the rich farmland seen today. Major Fenland draining began in the seventeenth century and brought Dutch engineers and their employees to the Peterborough area to work on this massive undertaking. The Dog in a Doublet was built as a coaching inn in the 1630s to accommodate this itinerant workforce.

The Netherlands had been draining land that was below sea level since the thirteenth century, but it was not until 1626 that Charles I employed Dutch

The Fens remained undrained until the seventeenth century.

engineer Cornelius Vermuyden to use these methods within the East Anglian Fenlands. Reclaiming land from the sea would extend the cultivatable acreage owned by the king, but local residents, who relied on the Fens for reed cutting, peat digging and fishing, were opposed to the drainage project. As soon as the Dutch workforce dug ditches and dykes, bands of Fenlanders undid their work by breaking sluice gates and dams to allow the water to flood back in. It was many years before Fen residents were compensated for their loss of livelihood and the sabotage ceased. However, regular flooding of the newly drained land still occurred because the peat-rich soil dried out and shrank below the level of drainage ditches and into the water table once more. It was not until the nineteenth century and the development of powered pumps that the Fenland water levels became stable and the land stayed consistently dry.

The Dog in a Doublet had served Fenlanders since the seventeenth century, but it was left to fall into disrepair during the twentieth century. After a twenty-first-century restoration, the building once more had the appearance of the original public house, with a simple design in white-painted brick and a tiled roof, and views over the land which was drained by the inn's original customers. The establishment was originally called 'The Bear' but gained its current name in the eighteenth century.

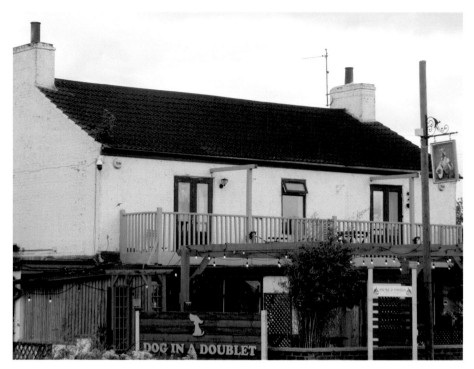

The Dog in a Doublet dates from the seventeenth century.

The landlady at the time owned a small dog that had a habit of drinking beer out of customers mugs and then falling into the river. As a consequence, the dog suffered from numerous chills and was made a padded coat to keep it warm. After that the inn was always referred to as the one with 'the dog in a doublet'.

12. Thorpe Hall (1656)

Thorpe Hall is a seventeenth-century mansion house that is now in use as a specialised Sue Ryder hospice. The gardens and parkland have a Grade II listing from Historic England while the hall, which has significance as being one of the few grand houses built during the Commonwealth period which followed the English Civil War, is listed Grade I.

The house was built by Oliver St John, a Parliamentarian whose military success in the Civil War afforded him the funds to buy medieval Thorpe Manor as a site for his new estate. The old house was demolished, and St John built Thorpe Hall using some of the stone from Peterborough Cathedral. Cromwell's Roundheads had destroyed parts of the ancient building in retaliation for Peterborough's Royalist stance and St John was given stone from the cloisters in recognition of his loyalty to Parliament. However, the stone blocks were refaced to prevent any carved religious decoration from being on show and offending Puritan beliefs.

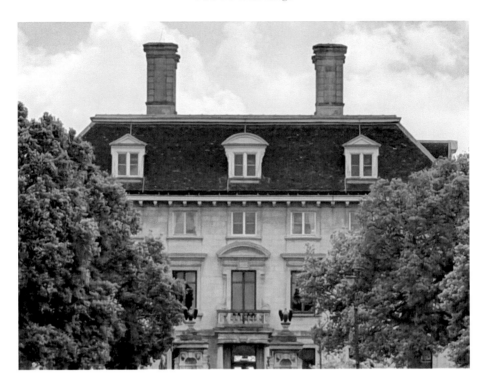

Above: Thorpe Hall was built during Oliver Cromwell's Commonwealth.

Right: Stones from the ruined cloisters of Peterborough Cathedral were reused.

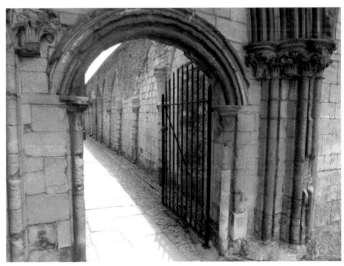

Thorpe Hall was designed by the nephew of Inigo Jones, John Webb, in a late Renaissance style. The house has a hipped slate roof with dormer windows and seven bay windows to the front. Decorative pediments and cornices surround the building, and the front porch has a balcony supported on Tuscan columns. The interior has many original details including intricate swag and scroll details in the plasterwork and grand marble fireplaces.

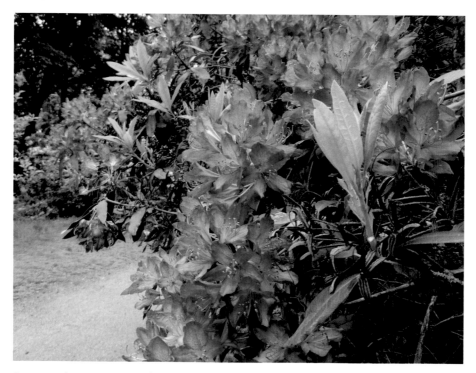

Seventeenth-century grounds were restored in the Victorian era.

When the last of the St John family died in 1789, the estate was sold. Thorpe Hall was occupied by various tenants until it was purchased by Revd William Strong in 1850. Strong was a horticulturalist who created a large kitchen garden near the house and restored the overgrown seventeenth-century grounds. He re-laid the paths in the parkland and lined them with the colourful rhododendron bushes that can still be seen today. The hall itself had fallen into disrepair by the time of Strong's ownership and he completely renovated the property to include Victorian features.

Thorpe Hall was bought for conversion into a maternity hospital 1947 and converted again into a Sue Ryder hospice in 1991. The gardens have since been restored to the Victorian planting scheme designed by Revd Strong.

13. Peterborough Guildhall (1671)

Peterborough Guildhall has historically been of both civic and commercial importance in the city. The Grade II listed building, which stands in Cathedral Square, is a focal point of the city centre and a popular meeting place for residents.

The seventeenth-century Guildhall was built to commemorate Charles II attaining the British throne after the years of Oliver Cromwell's Commonwealth.

In 1660, Peterborough's feoffees decided to build a structure that could replace the old moot hall and the dilapidated buttercross, where Peterborough's dairy and poultry markets had been held, and also celebrate the Restoration of the Monarchy.

Architect John Lovin was commissioned, and he designed the Guildhall to resemble a popular painting of the time, *The Old Town Hall in Amsterdam* by Pieter Jansz. It took over a decade to design and complete and was unveiled in 1671. Local limestone was used throughout and stone slate was used on the hipped roof. All elevations have both dormer and mullioned windows and the central gable with the insignia of Charles II is a centrepiece to the design. The open arcade below the Guildhall meant that poultry and dairy trading could continue as it always had, and an iron spiral stairway led to the upper room, which was called the Chamber Over the Cross. Here the feoffees held meetings about matters of city governance.

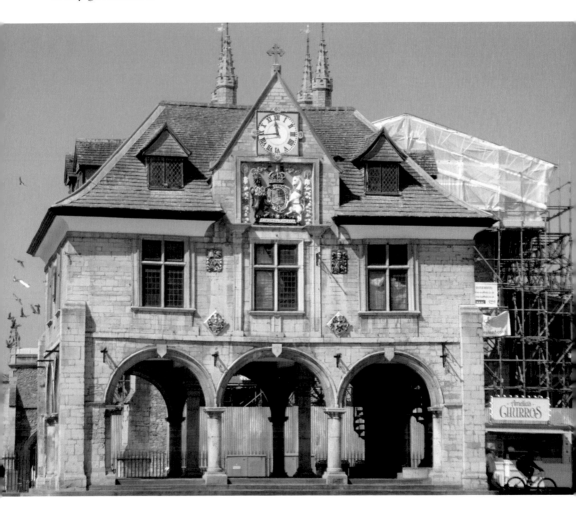

The Guildhall is an impressive part of Cathedral Square.

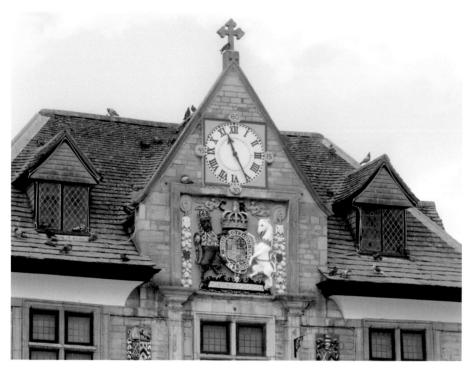

Charles II's crest commemorates the Restoration of the Monarchy.

In 1929, the building had a complete restoration and, although it was still used by Peterborough Council, it was enclosed by iron railings and no longer a market site. When the Town Hall was opened in 1933, the Guildhall was left empty. It remains a symbol of Peterborough's civic past, and the continuing importance of the building was recognised in 2012 when it was a starting point for the Olympic flame on its relay through Great Britain.

14. John Clare Cottage (c. 1690)

John Clare Cottage is in the village of Helpston, just to the north-west of Peterborough. It was where the poet John Clare was born in 1793 and the picturesque building has been preserved to become a museum of his life and works.

John Clare spent his childhood and a large part of his adult life in the cottage that now bears his name. At the time, the building was divided into accommodation for five families and living and working conditions were poor. Clare worked with his family in the fields and gardens of nearby Woodcroft Castle from a young age and this background in a poor rural area led to John Clare being known as the 'peasant poet'. However, Clare did well at school and he began to write poems to raise a

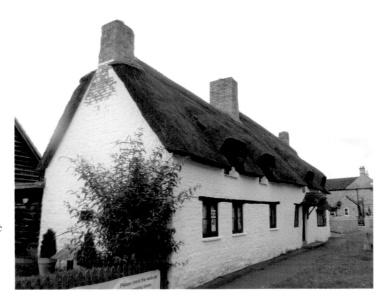

Poet John Clare
lived in the
picturesque
village of
Helpston.

little money to help the family meet the rent on the cottage. A local bookseller
greatly admired his work and sent it to a publisher, who released Clare's first book
in 1820. His poetry was well received and he earned a comfortable income for
the family. However, Clare's mental health deteriorated and his finances dwindled.
Friends helped him to move out of the family home and rent a property in nearby
Northborough, but he became so unwell with depression that he voluntarily entered
a private asylum in 1837. John Clare, now regarded as one of the great Romantic
poets, died in an asylum in 1864. His wish was to be buried at Helpston, next to his
parents, and his tomb can be seen in St Botolph's churchyard in the village.

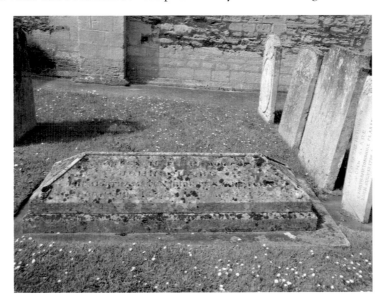

The grave of
the 'peasant
poet' in
St Botolph's
churchyard.

The seventeenth-century thatched cottage in which John Clare was born has since been converted from its original five dwellings to become a single property. The building is constructed out of stone rubble that has been whitewashed many times and has a ground floor with an upper floor under the eaves. The cottage was purchased by the John Clare Trust in 2006 and restored using only traditional building methods. It has a Grade II listing from Historic England.

15. Old Customs House (c. 1740)

The Old Customs House was built in the eighteenth century as a warehouse for goods that were being transported to and from Peterborough along the River Nene. Despite many developments in the surrounding area, it has survived to be the last historic waterfront property in the city centre and is now protected by a Grade II listing from Historic England.

The building dates from a time when Peterborough was busy with barges travelling along the River Nene towards Wisbech and the sea. Traders dealt in bricks, grain and other goods that were too heavy or bulky to be efficiently carried by road. The premium riverside location of the Old Customs House suggests that it was owned by a particularly wealthy merchant. Although it is known as the Old

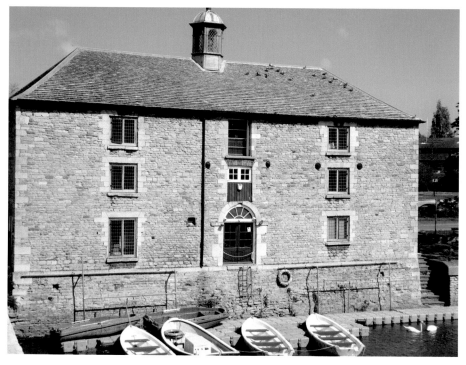

Riverside warehouses were used to store goods for transportation.

Customs House, the building was never used for the payment of duties and the origin of the name is unknown.

By the mid-nineteenth century the railways had become the main source of transportation and the river trade all but ceased. The Old Customs House was no longer used by merchants and was occupied by a boatbuilder for many years before being rented out as accommodation. Even by the 1920s, when the surrounding warehouses and waterside properties were derelict, the building was still being lived in. However, the area around the Old Customs House was cleared to make space for major civic improvements during the early 1930s and, as the dilapidated buildings that were clustered around it were gradually demolished, the architectural and historical importance of the Old Customs House could finally be appreciated. The tenant was rehoused and the building was restored to become a part of Peterborough's commercial heritage.

The Old Customs House is stone built and has a hipped slate roof with a hexagonal cupola and weathervane. The front and riverside doors are both of a typically Georgian style and each have an arched fanlight. The entrance on the waterfront has been placed at a high enough elevation to prevent flooding and has an iron ladder to access it during low water levels. The building is owned by Peterborough City Council and since 1942 it has been headquarters for the Peterborough Sea Cadets.

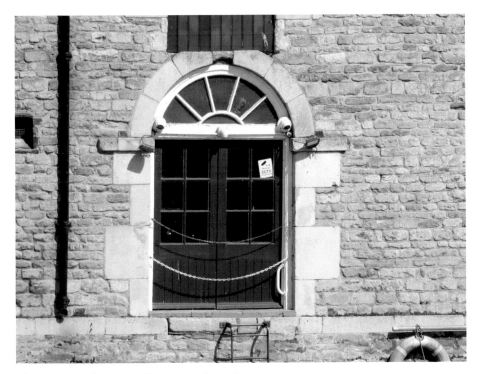

The Georgian doorway offers access from the water.

16. Alwalton Hall (1774)

Alwalton Hall is a Georgian country house to the west of Peterborough. The oldest part of the building dates from 1774 and the property has a Grade II listing.

In the eighteenth century, Earl Fitzwilliam commissioned architects to design his new family home. The result was a large red-brick property, which he named Alwalton House. The house passed to the next generation in 1833 and the new Earl Fitzwilliam changed the building completely. Between 1841 and 1851, a large limestone extension was added and the old house was plastered and painted to become the service wing. The new part of the building had cellars put in but followed the roofline of the Georgian original with Welsh slate tiles and a hipped design. The property was renamed Alwalton Hall to represent its larger size and more opulent style.

In 1948, Alwalton Hall was purchased by engineer and businessman Frank Perkins. Born and bred in Peterborough, Perkins began a small enterprise in 1932, which grew to become the Perkins Engine Group. With a degree in mechanical engineering and a family history in agricultural machinery, Perkins and his business partner, Charles Chapman, developed a new lightweight diesel engine that was faster and more reliable than any that had previously been made. Within a year their diesel engine held the world speed record, and business rapidly grew. They moved their plant to the Eastfield site in 1947 and Perkins bought Alwalton Hall as his family home the following year. He died at home in 1967, but the Eastfield site is still a major local employer and makes half a million engines a year. Frank Perkins has a memorial in Alwalton parish church. Henry Royce, the cofounder of Rolls-Royce, was born in Alwalton village and is also commemorated in the church.

Alwalton Hall has stayed in private ownership and was bought by the current owners in 2004. Since 2017, part of the hall has been run as a day spa promoting health and wellbeing.

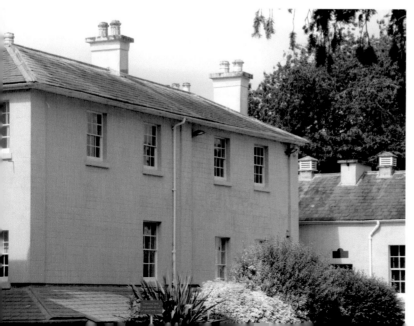

The service wing was created from the original Georgian property.

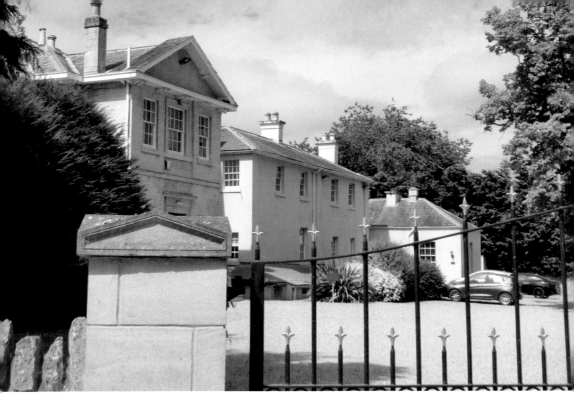

Alwalton Hall offers a tranquil space for health and wellbeing.

17. Norman Cross Prison (1797)

Norman Cross Prison was located on the outskirts of Peterborough and was the first purpose-built prisoner-of-war camp ever constructed. Up to 10,000 captured French soldiers were held there during the Napoleonic Wars. Two buildings have survived from the vast site and a separate monument commemorates the prisoners who did not live to be repatriated.

Norman Cross Prison was hastily devised and built in 1797. The British military were taking many more prisoners in the Napoleonic Wars than they had anticipated and had nowhere suitable to detain them all. The idea of one large camp was proposed, and in just three months Norman Cross was ready. The location was ideal as it was close to the Great North Road and made transporting prisoners, along with and the large quantity of supplies needed to feed them, much easier. Thousands of prisoners arrived, and they were treated with respect. Men from the lower ranks were housed in comfortable dormitories, while the officers were allowed out on bail in private houses, where they had access to their own finances and became a part of Peterborough high society. Those who were kept in the camp spent much of their time developing skills in crafts and art. They learned to carve both wood and bone and sold their models in the marketplace to local people in exchange for goods and tobacco. Some prisoners became so skilled in art

Above: Napoleonic prisoners of war are remembered at Norman Cross.

Below: The prison's governor lived in a large Georgian house.

Norman Cross camp could be seen from the governor's garden.

that wealthy residents commissioned works from them. Peterborough Museum has collections of many exceptional items made by the prisoners at Norman Cross.

The layout of the prison was based on the design for artillery forts at that time. It had wooden accommodation blocks with a central guard tower and lookout towers around the outer wall. A deep ditch was dug just inside this perimeter wall where guards could patrol without being seen by any prisoners who might be waiting for an opportunity to escape. The ditch can still be seen as an earthwork. Permanent remains from the camp are the houses that were occupied by the governor of the prison and the barrack master. These both have a Grade II listing from Historic England.

The two properties were built in 1797 and sold off when peace was declared in 1814. The Old Governor's House is a three-storey building of a classical Georgian style in rendered brick with sash windows and a central portico. The barrack master's house is now known as Norman House and has a similar design. It is white painted with stone details and has decorative screen walls to each side. The doorway is the Georgian original, but the porch was a Victorian addition. Both houses are now private residences, while the converted stable block is used as an art gallery.

18. Museum and Art Gallery (1816)

Peterborough Museum and Art Gallery is housed in a late Georgian property on Priestgate. The building was built as a large private residence and went on

to become Peterborough's first public hospital before being converted into the museum in the 1930s.

In 1816, Thomas Alderson Cooke, a renowned Peterborough magistrate, commissioned a grand family home to be built on Priestgate. It replaced a large timber-framed house from the sixteenth century, but the stone cellar and steps from this earlier property were reused and are still below the museum today. Cooke's new house had impressive architecture and reflected his wealth. It was built in the Greek Revival style with a large central portico and enough space between the doorway and the street to allow coaches to pull up outside. After Cooke died, the house was sold to the Fitzwilliam family, who in 1856 donated it to the city to be converted into a much-needed hospital. The hospital moved to a larger site in the 1920s and soon afterwards the Priestgate property underwent extensive renovation work. It reopened as Peterborough Museum in 1931 and was one of the new municipal facilities created in Peterborough at that time.

The museum exhibits had been collected by the Peterborough Natural History, Scientific and Archaeological Society since the nineteenth century and they welcomed the ability to finally put their array of interesting antiquities and artefacts on display. The collections are constantly added to, and Peterborough Museum now holds original manuscripts written by poet John Clare as well as works of art that were made by French prisoners at nearby Norman Cross Prison. There is also a preserved Victorian operating theatre from the building's previous use as a hospital. The Museum and Art Gallery is now run as a not-for-profit venture on behalf of Peterborough City Council.

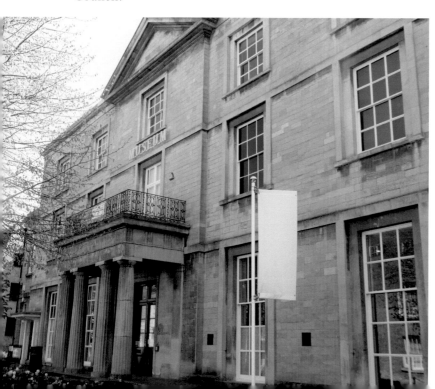

Peterborough Museum and Art Gallery is housed in a Georgian mansion.

The exhibitions have been open to the public since 1931.

An attractive setting brings many visitors to the art gallery.

19. Old Gaol (1842)

The Old Gaol stands on Thorpe Road and was constructed in 1842. It was built to house the growing prison population of Peterborough but later became the headquarters of the Liberty of Peterborough Constabulary and also a magistrates' court.

The early part of the nineteenth century saw many new jails being built due to a rapid increase in the number of convicts needing incarceration. The Old Gaol

could hold a maximum of 200 inmates and replaced two others in Peterborough, the Abbots Gaol and the House of Correction. It was designed by W. J. Donthorne, a founder member of the Royal Institute of British Architects, and was of a similar design to that of Pentonville Prison in London. It was designed in a Noman style in stone with a central entrance tower, turrets and two tiers of machicolations, or arrow slits. The doorway had a working portcullis fitted although it was never used.

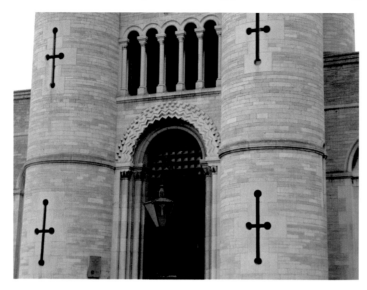

Left: The building was designed in Romanesque Revival style.

Below: The Old Gaol is also known as the Sessions House.

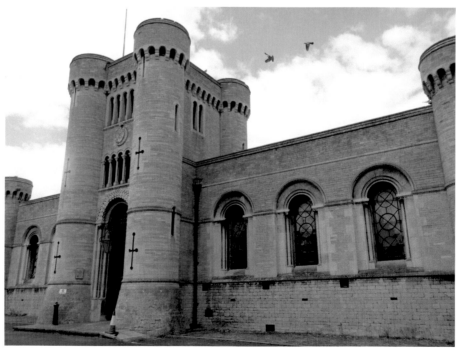

When the prison system was nationalised in 1878, the building was occupied by the Liberty of Peterborough Constabulary, who were the local police force between 1857 and 1947. They used the Thorpe Road property until becoming part of the Peterborough City Police in 1947. There was also a courtroom in the building during this time that heard both the petty and quarter court sessions. This resulted in the property becoming more commonly known as the Sessions House. It remained in use as a courtroom until 1986.

The Old Gaol was converted to become a restaurant and public house in the latter part of the twentieth century and named 'The Sessions House' after its courtroom history. It is a Grade II listed building.

20. Engine Shed (1848/2018)

Peterborough got its first railway line in 1845, which connected it with Northampton, 40 miles away. From this beginning, the rail network was constantly expanded and improved upon and brought employment and prosperity to the city. Due to continual developments, most of the maintenance buildings and infrastructure from the early years of railway history have been lost. However, among the twenty-first-century buildings of Fletton Quays is Sand Martin House, a new property that has incorporated an early locomotive shed as part of its design.

Sand Martin House is the site of the city council's new offices and consists of a modern building connected by a glass atrium to the Victorian engine shed. The engine shed is one of the earliest surviving examples of its kind and was built in 1848 by the Great Eastern Railway. The building was made of brick and

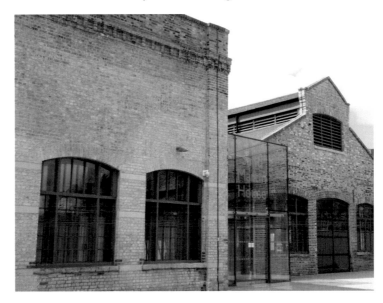

Sand Martin House has repurposed historical railway architecture.

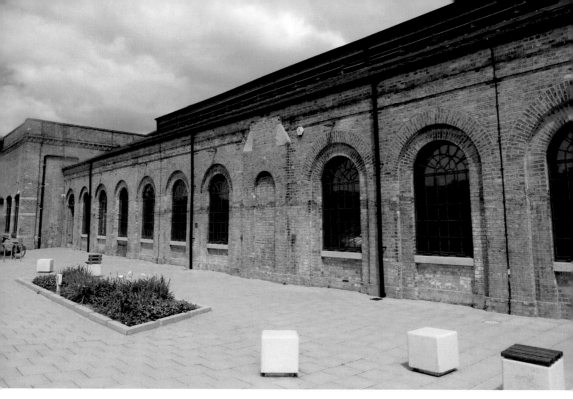
The restored brick engine shed has Grade II listed status.

contained six tracks with a turntable. Forty locomotives could be housed there alongside water tanks capable of holding over 70,000 gallons of water. By the 1930s, railway traffic was moving away from the area to new facilities at nearby March, and the engine shed was closed in 1939. By the 1960s, the building was being leased for industrial use and its condition began to deteriorate. Although it was given a Grade II listing in 1992, the locomotive shed became derelict and was further damaged by a fire in 2007. To save this historic building, the architects responsible for the Fletton Quays redevelopment project incorporated it into the design for Sand Martin House. A lot of the brick structure and some internal details had fortunately survived the fire and could be restored, while the rest was reconstructed. The engine shed is now lined with clear glazed offices that retain the industrial feel of the property that displays its railway heritage.

21. Nene Viaduct (1850)

The Nene Viaduct is just to the south of Peterborough railway station, at the point where the East Coast Main Line crosses the River Nene. The three-arch bridge is unique as it is the last piece of cast-iron engineering still in use on a mainline railway. For this reason, it has been given a Grade II listing by Historic England.

The viaduct was built in 1850 to carry the Great Northern Railway. It was designed by engineer Sir William Cubitt and his son, Joseph, and was constructed in cast iron

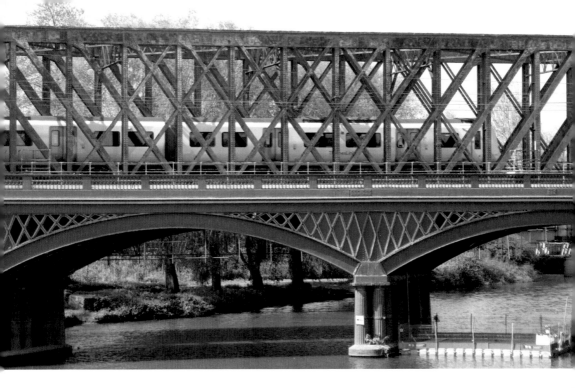

Above: The bridge is over 170 years old.

Right: Cast-iron details on the Nene Viaduct.

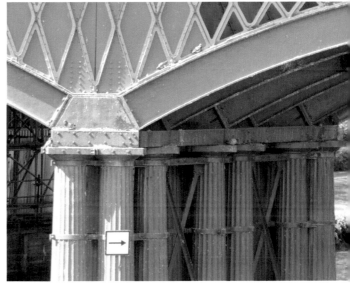

with facings of both white brick and stone. The building process involved sinking caissons into the bed of the Nene to create a stable base on which to build columns. The columns would then support the weight of the metal spans in combination with the blue brick abutments on the riverbanks. The viaduct was strengthened in the twentieth century and high-speed modern trains now use it every day. When the railway links for Peterborough were expanded in 1924, a second bridge was erected to carry the additional lines. This steel construction is abutted to the Nene Viaduct

and stands taller than it. However, the aesthetic quality of the original, which features Doric columns and decorative metal latticework, still stands out.

22. Great Northern Hotel (1852)

The Great Northern Hotel was built in 1852 opposite Peterborough's railway station. It provided accommodation and hospitality for travellers on the Great Northern Railway and, over 150 years later it is the only purpose-built railway hotel that still fulfils this original function.

The hotel was designed by the GNR's chief architect, Henry Goddard, and built soon after the railway line came to Peterborough. The west front of the hotel has a late Georgian style. The ground floor is constructed in stone, while the two upper levels are brick. A decorative cornice divides the two building materials and continues around the entrance porch to give simple elegance to the façade. Extensions were made in both 1855 and 1859, and these have a similarly classical style.

The Great Northern was a popular hotel but was forced to close to customers at the onset of the Second World War. However, the head office of the GNR moved in after relocating from King's Cross when they became concerned about air raids. It is said that the hotel suites became temporary homes for many wealthy and famous people who also moved out of London during the war.

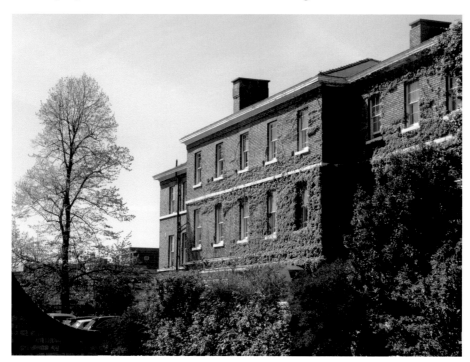

The property has an unpretentious late Georgian style.

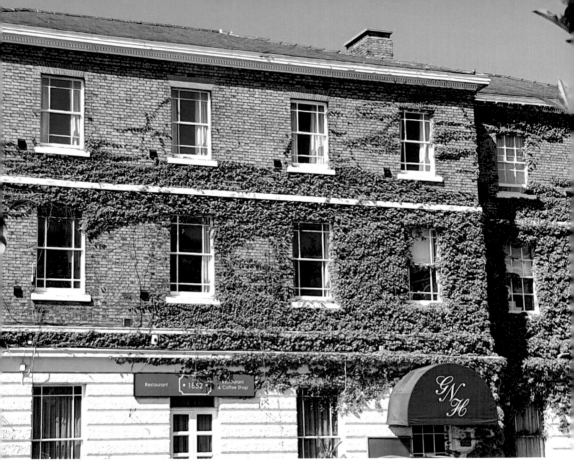

The Great Northern Hotel is proud of its railway heritage.

The Great Northern reopened in 1949, but trade at the hotel began to decline towards end of the twentieth century. It was sold a number of times and in 1993 the hotel was bought by Peterborough entrepreneur and philanthropist Peter Boizot, who invested in the Great Northern and made it a financial success once again. Peter Boizot was born in 1929 and went on to create the PizzaExpress food brand in the 1960s. The millionaire invested a lot of his time and money in his home city. He bought Peterborough United Football Club to save it from collapse and also renovated many local commercial buildings. He completely refurbished the Great Northern Hotel and continued to invest in it for many years. It was sold not long before Boizot died in 2018. The Great Northern is still a highly regarded hotel for rail passengers.

23. Westgate Church (1859)

Westgate Church is now the home of the Universal Church of the Kingdom of God, but it was originally built for Peterborough's Congregational community in 1859. It was designed in the Gothic Revival style by prolific church architect Robert Moffat Smith.

Church communities increased with Peterborough's economic prosperity, and expanding congregation numbers meant that there were more funds available with which to build new places of worship. The Congregational Church bought a site for a new church and commissioned Moffat Smith to create the striking piece of architecture that stands on Westgate today.

The Congregational Church merged with the Presbyterians to form the United Reformed Church in the 1970s but continued to hold services in Westgate until the early twenty-first century. At this time there was a further merger with Peterborough's Methodists and the combined congregations now meet in a nearby modern building and are known as Westgate New Church. The older church building was subsequently sold.

Westgate Church was purchased in 2016 by the Universal Church of the Kingdom of God. The interior has been modernised, but Moffat Smith's exterior has been preserved and the typically pointed features of Gothic architecture are seen in the Revivalist design. The front elevation is dominated by a large traceried window and also by the two projecting buttresses that each rise up to form slender spires above the slate roof. Westgate Church has stained-glass windows made by John Ward Knowles, who used his knowledge of medieval glass-making techniques and designs to complement Moffat Smith's architecture. This Nonconformist interpretation of Gothic architecture remains a focal point of Westgate.

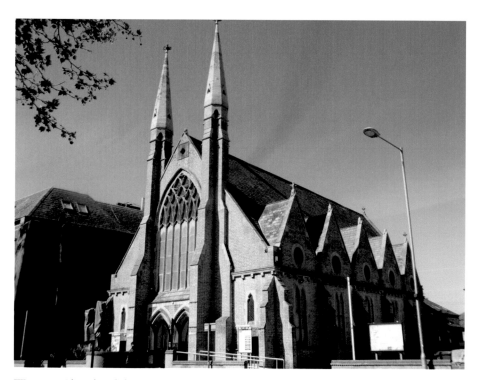

Westgate Church exhibits Gothic Revival architecture.

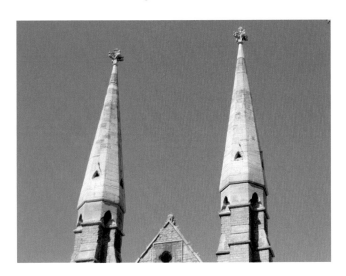

Twin spires are a
commanding feature.

24. Former Masonic Hall (1864)

The former Masonic Hall is an attractive stone and brick building on Lincoln
Road. It was used by the Freemasons until the early twenty-first century when it
was altered to become a restaurant.

The former Masonic Hall is now a restaurant.

A variety of building materials have been used.

In 1864, local architect R. Chamberlain was commissioned by Peterborough Freemasons to design and build a Masonic Hall for them. At the time, Lincoln Road was being developed and fashionable Victorian properties were replacing older, mostly commercial, buildings. The development area had been occupied by Squires Brewery and its adjacent maltings and these were systematically pulled down as works progressed. The Masonic Hall was built as part of this development and eighteenth-century building materials, which had been left after the maltings were demolished, were reused in its construction.

The Masonic Hall was built with limestone rubble from the old brewery buildings and the walls were then embellished with brick and stone detailing. The front elevation has mullioned windows and a solid brick parapet at the roof line. A tall central chimney is a design feature to recognise the site's previous use as a maltings.

The Masonic Hall was used until the turn of the twenty-first century when it became difficult to host large events there due to the size of the venue and parking issues. A new Masonic Hall was built in Bretton and the large modern structure has plenty of car parking space available.

25. Peterscourt (1864)

Peterscourt was originally built as the St Peter's Teacher Training College. It was designed by the renowned architect Sir George Gilbert Scott and the Gothic Revival building on City Road has a Grade II listing from Historic England.

St Peter's opened in 1864 and for fifty years it exclusively accepted male student teachers. The college closed in 1914, when many trainees enlisted at the onset of the First World War, but it reopened in 1921. Society had changed in the intervening years, however, and St Peter's now openly invited female applicants. For the next seventeen years both women and men gained teaching qualifications from the college and went on to teach in many of Peterborough's schools. In 1939, war in Europe caused the college to close once again and, for the duration of the war, the building was used as a club for American servicemen. Afterwards, it was converted into offices and the name of the property was changed to Peterscourt.

Sir George Gilbert Scott designed Peterscourt to make the best use of local building materials. Red bricks are used throughout, complemented by the red tiles of the roof. Subtle detailing in blue brick enhances the property. The building has a symmetry that is created by the evenly spaced chimney stacks and, with the dormer and lancet windows, Peterscourt displays a typical Neo-Gothic style.

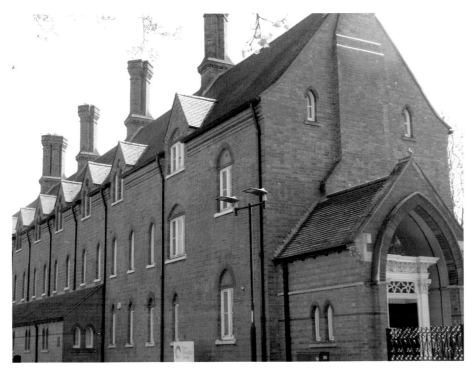

Peterscourt was originally a teacher training college.

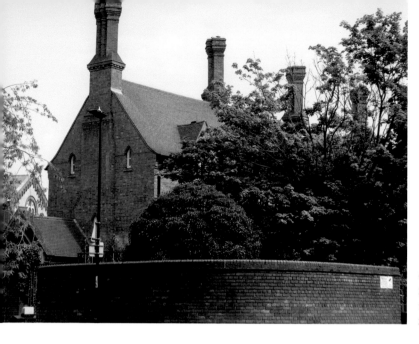

George Gilbert Scott made good use of local building materials.

There have been few alterations made to the building, apart from a doorway that was put in place during the mid-twentieth-century modification into offices. This door was recovered from the London Guildhall after the ancient building had been badly damaged during an air raid in 1940. Giles Gilbert Scott, the grandson of Sir George, was chief architect on the subsequent repairs and did not reuse the eighteenth-century doorway in his design. Instead, it was sent to Peterborough and utilised in Peterscourt. The antique timber doorway is now a main entrance.

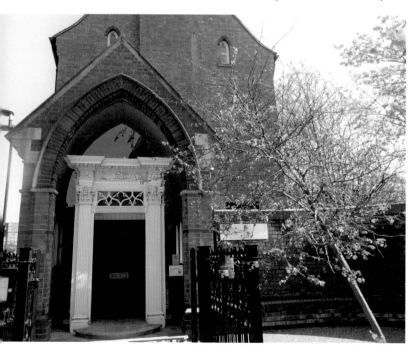

The door was moved from the Guildhall in London.

It has an intricately carved decorative fanlight and Corinthian pilasters and is still painted in its original colours.

Peterscourt was fully restored and refurbished in the 1980s and again in the 2010s when it became a complex of serviced offices known as the Eco Innovation Centre. This eco-friendly work space promotes Peterborough's strong environmental policy.

26. Trinity Presbyterian Church (1864)

On the corner of Priestgate and Trinity Street is the Trinity Presbyterian Church. This late Georgian-styled building, with its small tower and octagonal spire, is no longer in use as a church but its original appearance has been preserved. The property is a prominent part of the street scene and has Grade II listed status.

Nonconformist worshippers in Peterborough began to increase in number during the Victorian era. Previously small congregations, who could worship in private houses, now needed separate buildings to accommodate everyone wishing to attend services. The Presbyterian Church found a suitable building on Priestgate, which they converted and consecrated in 1864. The church was adapted from an earlier private house, a tower and spire were added and alterations made to

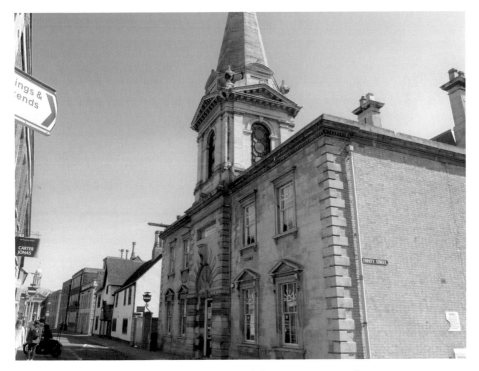

The Trinity Presbyterian Church was converted from a private residence.

The stone building is an attractive addition to Priestgate's architecture.

open up the interior. The building has a stone façade and slate roof. Ornamental pediments over the ground-floor windows are repeated again in decorations on the tower, while the shape of the door surround is echoed in the coloured glass window below the spire. The doorway is accentuated by protruding stonework and a decorative stone fanlight.

The Trinity Presbyterian Church attracted a large congregation for over a century. However, the site was no longer used after the Presbyterian and Congregational churches combined to form the United Reformed Church in 1972. The Priestgate building was sold after the newly merged congregation moved to Westgate. The site is now used as a children's nursery.

27. The Lindens (1865)

The Lindens stands on Lincoln Road and is a notable example of Arts and Crafts design. The house has been extended in recent years but has retained many original features.

The property was built between 1860 and 1865 by leading architect and master builder John Thompson. Thompson was born in Peterborough and became renowned for his work on the major cathedral restorations that took place in Great Britain during the late nineteenth century. The Lindens was to be his family home until he died in 1898, and during that time he twice became the city's mayor. After his death, The Lindens was bought by wealthy hotelier Alfred Paten, who offered the house for use as a military hospital during both the First and Second World Wars. The philanthropist later bequeathed it to Peterborough Council for public use.

The Lindens was converted in the twentieth century to become sheltered accommodation, but still displays many attractive period features. The half-timbered gables and white brickwork are of a typically Arts and Crafts design

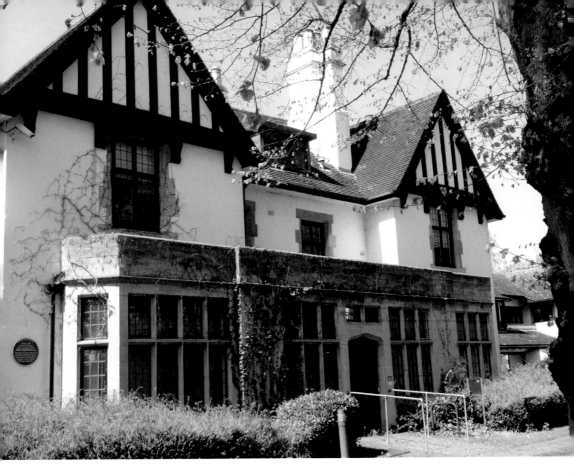

Above: The Lindens was built by a leading Peterborough architect.

Right: Arts and Crafts details are a feature of the property.

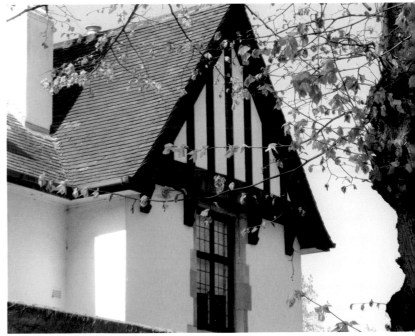

while the stone doorway and mullioned windows add Gothic Revival detailing. Inside the property, the original grand staircase has survived the major alterations and is lit by a large window in the stairwell that incorporates Victorian stained-glass panels. Some of the linden trees from which the property gets its name still grow in the garden.

28. Nelson House (1868)

Cowgate is one of the oldest streets in Peterborough. In the medieval period it was the route used by livestock drovers to leave the walled city for the grazing land beyond, and this original purpose is reflected in its name. Peterborough has changed over the centuries and Cowgate has also altered and been rebuilt many times. Although it has kept its original name, it is now a street of mainly commercial properties with undatable shopfronts that have been built since the mid-nineteenth century. However, above the shopfronts are uppers storeys with interesting features. A notable building is No. 34 Cowgate, known as Nelson House, which has gained a Grade II listing from Historic England for its curiosity value.

The ancient thoroughfare of Cowgate has been continually updated.

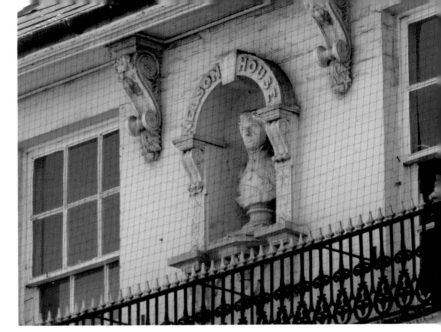

Many curiosities can be found on upper levels of buildings.

Nelson House was constructed in 1868 to replace an older structure. It is built of Fletton brick and has a slate roof. The overhanging eaves have decorative supports and the top floor also has a niche containing a bust of Admiral Lord Nelson. The arched keystone above it is carved with the name of the property. The figure has been painted in blue and it contrasts against the painted white brickwork. Below the bust is a cornice topped with cast-iron guard railings. At street level the building is modern and commercial, but the upper architectural details give it a unique Victorian character.

29. Wagon Repair Shop and Lathe House (c. 1872)

During the early years of rail transport in Peterborough, many different railway companies operated in the city and each had their own sites full of locomotive sheds and maintenance workshops. The Midland Railway was just one of these organisations and they had a vast area for repairs on their trains and carriages. However, only two of the numerous service buildings they erected have survived. A Victorian wagon repair shop and lathe house, situated near the site of the now demolished Peterborough East station, have therefore become an important part of the heritage of Peterborough.

They were erected in the 1870s and Historic England have awarded them Grade II listed status. The repair shop is a timber-framed building with wooden cladding and iron-framed windows. The roof slates were replaced in the mid-twentieth century and the Victorian wooden floor was concreted, but otherwise the building is completely original. It has four gabled repair bays, all of which are still used by the railway today. The repair shop is adjoined by its lathe house. This is also of a timber construction and still has its original Welsh slate roof tiles. The two

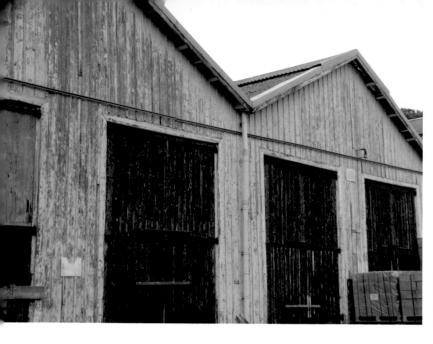

Original Victorian workshops are still used by the railway today.

buildings have become unique examples of their genre and are the oldest in the country still used for their original purpose.

30. Gladstone House (1879)

Gladstone House is a terraced property on the corner of Gladstone Street. It is the headquarters of the Gladstone District Community Association, or GLADCA, who have been working on behalf of neighbourhood residents for nearly fifty years. The property also has a link to the *Titanic* tragedy, and this has been commemorated by the Peterborough Civic Society, who have placed a blue plaque on the building.

In 1901 John and Annie Sage moved into the property and ran it as a bakery. A few years later John and the eldest of his nine children went to the USA to find a new life for the whole family. They purchased a farm in Florida and returned to Peterborough to sell up and emigrate. The family booked to sail in 1911 but the coal strike postponed their travel date to April 1912. Their passage was to be aboard the *Titanic*. Four days into their voyage the ship hit an iceberg and sank, taking the entire Sage family down with it. Eyewitnesses later said they saw a little girl who they believed to be one of John and Annie's daughters refuse a lifeboat place to stay with the rest of her family. Theirs was the biggest recorded loss of life any one family suffered in the *Titanic* disaster.

Their old home on Gladstone Street was used as a domestic residence until the 1960s when it became the headquarters of GLADCA. This charity was established by the local community and has consistently offered support to minority groups and promoted inclusivity. Gladstone House has a modest appearance. It is a brick-built corner terrace with a plain tiled roof, bay windows and porch, but it is at the heart of social support within its community.

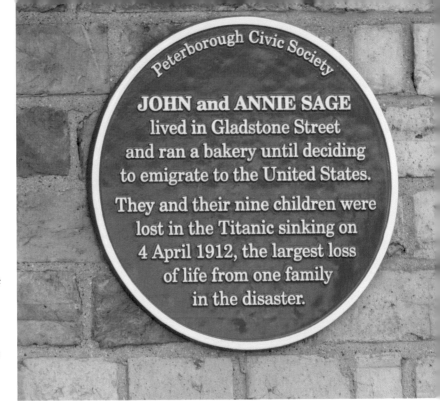

JOHN and ANNIE SAGE lived in Gladstone Street and ran a bakery until deciding to emigrate to the United States.

They and their nine children were lost in the Titanic sinking on 4 April 1912, the largest loss of life from one family in the disaster.

Right: Peterborough Civic Society have recognised the building's moving history.

Below: The house is now a hub for community support.

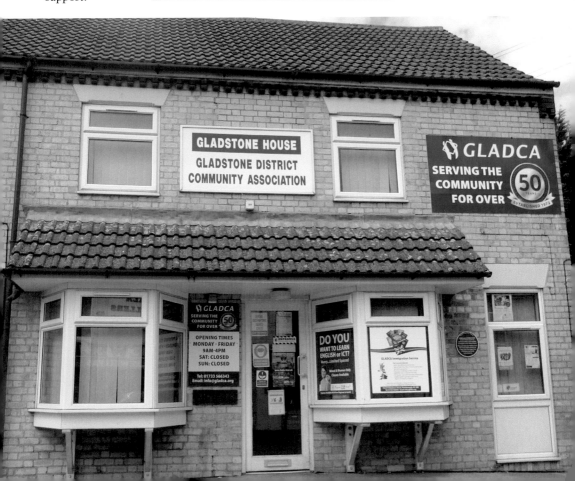

31. King's (The Cathedral) School (1885)

The King's (The Cathedral) School stands on Park Road and was built in 1885. However, the history of the school dates back to 1541 when it was founded by Henry VIII in the grounds of Peterborough Cathedral. Despite the change in location, the school retains its close associations with the cathedral and teaches all of the cathedral's choristers.

Henry VIII closed many religious buildings during the Dissolution of the Monasteries, but he also established a number of new Anglican schools that were each named The King's School in his honour. In Peterborough, an allowance was given to teach twenty boys from pauper families at The King's School. The schoolroom was in the St Thomas a Becket Chapel and pupils also learned music in the chamber above the Great Gate. The school accepted an increasing number of pupils and eventually it was necessary to build a much larger premises if it was to continue. In the late nineteenth century, The King's School secured a site on Park Road for a new building, which was completed in 1885.

John Thompson and Sons were contracted to design and construct the property; the characteristic Arts and Crafts styling of the Peterborough architect can be seen in

Music lessons were held above the Great Gate.

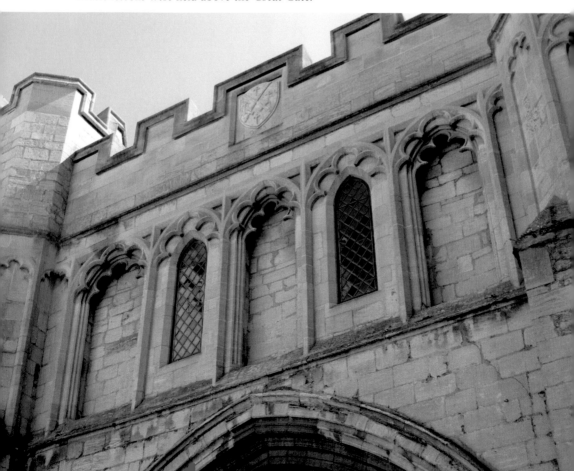

gabled slate roofs and a castellated entrance tower. Mullioned windows with stone surrounds provide a lot of natural interior light and where stone has also been used in the door surrounds, it contrasts against the red brick to create a decorative effect. Inside the school, the spacious common areas have wooden roof beams and there are multiple corridors and staircases that link the older wings of the school with newer extensions.

The King's School was for boys only for over 400 years and during that time it exclusively employed male staff. A shortage of male teachers during the Second World War led to women finally being appointed and these new teachers went on to greatly improve the school's academic standard. Nonetheless, it was not until 1976 that female pupils were admitted. In 2011 the school changed its name to The King's (The Cathedral) School. Former pupils are known as Old Petriburgians and one of these was Peter Boizot, the Peterborough entrepreneur who created the PizzaExpress brand.

The King's School has typically Victorian architecture.

All choristers at Peterborough Cathedral are taught at the school.

32. The Gables (1895)

The Gables is a Grade II listed property on Thorpe Road. The building is noted for its architectural style and detailing, which are characteristic of the architect John Alfred Gotch. This renowned architect also designed Peterborough Town Bridge. The Gables was built in 1895 for a wealthy local businessman as a family home but was later extended and converted into a maternity hospital. Twenty-first-century restorations have returned The Gables to residential use.

John Alfred Gotch established his practice in 1878 and had a successful business for fifty years. He was also an architectural historian with a particular expertise in the Tudor and Jacobean eras. The Gables displays Gotch's characteristic style, which is influenced by these periods. The building has been constructed in red brick with limestone dressings and a tiled roof. The gabled bays on the main façade have mullioned windows, which echo those of Tudor buildings and are a typical Gotch feature. A spectacular fifteen-light, three-tier window dominates the back elevation and allows daylight into the interior stairwell. The property retains some of its Victorian fireplaces and overmantels and there are original ceilings with decorative plasterwork. The floorplan of The Gables has been retained despite its changes of use, although some of the larger rooms have been partitioned. There have been some modern additions, including a ramp to the

The Gables has been converted into apartments.

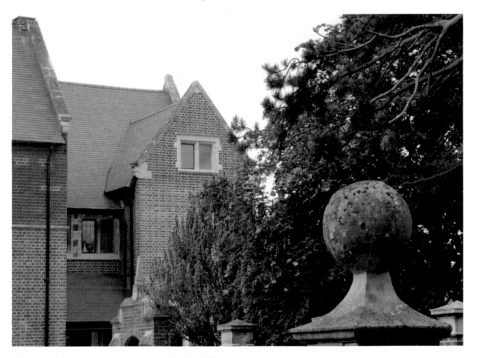

Using gables as a feature gave the building its name.

main door and an extension containing service rooms. However, the character of The Gables has been preserved in its decorative details and excellent quality Victorian craftsmanship.

33. Phorpres House (1899)

Phorpres House is an impressive property on London Road and it illustrates the importance of the brick industry to Peterborough's economy. The property was named after the 'four-press' method used to make local Fletton bricks and built by the owner of the London Brick Company. The company used the building as offices for many years, but it has since become residential.

There has been a brickmaking industry around Peterborough for many centuries. However, early methods used surface clay, which needed weathering before use, and it was a labour-intensive and seasonal trade. In the nineteenth century, Fletton Lodge brickworks developed a mechanised way to obtain much deeper clay deposits, which could be used without further processing, and the industry became more efficient and profitable. The extraction method was adopted by the many local companies who gradually merged to become known as the London Brick Company. Despite its name, the business was based in Peterborough and the local economy thrived due to Fletton bricks.

Phorpres House was built by the London Brick Company.

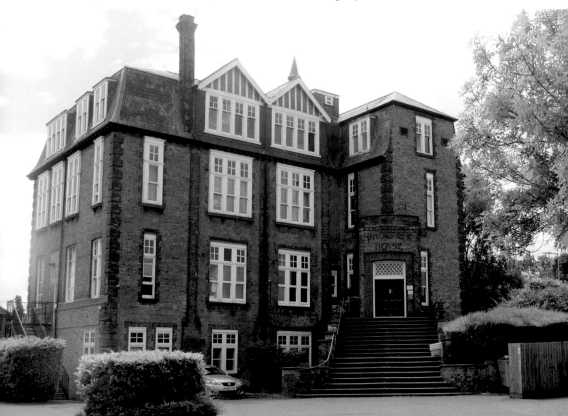

Architect John Cathles Hill bought the London Brick Company in 1889. He was a considerate employer and, in 1899, bought a site on London Road with the intention of building a social club for his workforce and their families. It was to be built in brick and named Phorpres House to reflect the local industry.

Hill designed the building personally. Details on the four-storey property include narrow mullioned windows and decorated roof edges, which have been influenced by the Arts and Crafts movement. The combined use of both red and yellow bricks creates an additional decorative feature. There are steps leading up to a first-floor main doorway and, with the slate mansard roof, this gives the property a grandeur that was unusual in a commercial property. It was perhaps for this reason that Hill did not fit out the interior as intended and the building was left vacant instead. Phorpres House was finally sold and became a mission room for a nearby Wesleyan congregation and then, during the First World War, it was occupied by a supplier of dried vegetables to the military. However, in 1928 the London Brick Company bought Phorpres House back and adapted it for use

The building has a grand entrance.

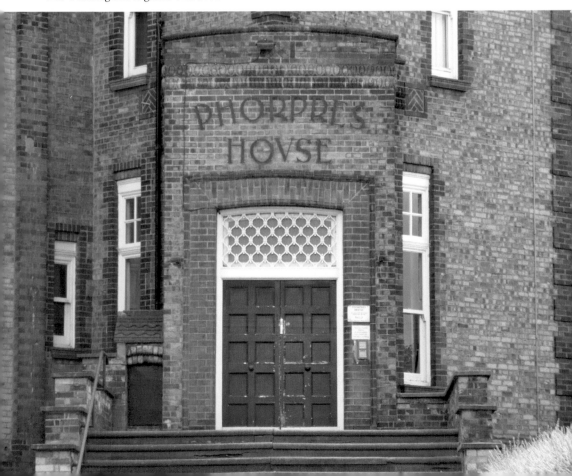

as their district offices. In the late twentieth century the property was sold again and converted into private apartments.

34. Miss Pears' Almshouses (1903)

Miss Pears' Almshouses are on Cumbergate. The property is now used as a bar and restaurant, but the early twentieth-century building was originally built as a replacement for Peterborough's deplorable poorhouse.

In the eighteenth century, the feoffees built a poorhouse on Cumbergate where the destitute of the city could find shelter. However, it soon became little more than somewhere to abandon the elderly and infirm when their families could no longer afford to support them and the conditions inside deteriorated quickly. In 1834, new laws were passed in Parliament to try to improve the circumstances of the homeless. It stated that those willing to enter a workhouse and earn their keep would be given proper food and shelter in return, but this proved not to be the case. Workhouse residents, including those in Peterborough, were exploited as cheap labour and many died of disease or malnutrition. By the turn of the

Miss Pears' Almshouses provided a comfortable home for the poor.

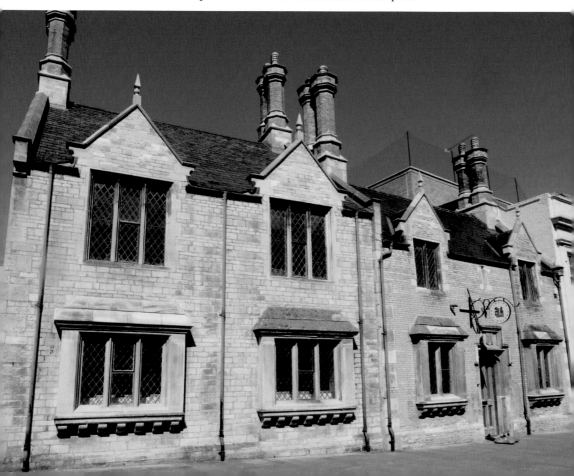

The stone building has attractive brick details.

twentieth century, charities were being established all over the country to replace these horrific institutions with something better.

In 1901, Peterborough resident Miss Frances Pears bequeathed £5,000 to improve the city's facilities for the poor. The workhouse was kept open but the poorhouse on Cumbergate was to be demolished and new almshouses, where the neediest in society would be given a comfortable home for as long as they needed it, was built in its place.

Architect James Stallebrass designed the new building to fit on the footprint of the old one and it was completed in 1903. It has a Neo-Gothic style with mullioned windows and stone doorway. Hexagonal brick chimneys rise above a slate roof and contrast with the stone walls. The gables are a dominant feature on this Grade II listed building. The almshouses were in use until 1969 when the building was sold by the council. It was sympathetically converted to commercial use and retains its original appearance and character.

35. Carnegie Library (1905)

The Carnegie Library is situated on Broadway and was built with funds provided by philanthropist Andrew Carnegie. The building is now used as a restaurant and the structure immediately to its right has become the main lending library for Peterborough. This new Central Library was built in 1990 when the Carnegie became too small to provide all the necessary services for the city.

The Carnegie Library was constructed in 1905 using Fletton bricks. The ground floor is faced with dressed stone and is set with five arched windows, all of which have decorative keystones and architrave, and the upper-storey windows have a

Peterborough's first library was funded by rail magnate Andrew Carnegie.

swag detail on the lintel. This gives the façade a classical look and the architectural details of the Carnegie Library are complemented by the angular design and pale brickwork of the newer library next door.

Peterborough first acquired a library in the eighteenth century when Peterborough Gentlemen's Society began a book club. The society gathered together a large collection of literature and decided to loan out the books to Peterborough residents. By the late nineteenth century, the Victorian desire for public education led to a call for each town to have a dedicated library and funding was secured to construct Peterborough's first library building. It was built during 1905 and was personally opened in May 1906 by Andrew Carnegie, the American rail magnate who had provided the funds. Carnegie was subsequently awarded the honour of Freeman of the City.

Peterborough's Carnegie Library served the city's public for eighty-five years until the larger City Library, which incorporates a theatre as one of its many

The new Central Library now serves the city.

community services, was opened to replace it. However, the Carnegie still stands as a testament to the generosity of the philanthropist whose name it bears.

36. Westgate Shopping Arcade (1927)

The Westgate Shopping Arcade was built in 1927 and became Peterborough's first indoor retail precinct. Nearly a century after it was constructed, the arcade retains its original character and is a stylish shopping destination consisting of small independent retailers.

Westgate had traditionally been the principal shopping street but did not have direct access to Cathedral Square and the market area. In the 1920s, the owners of the outbuildings and yards between Westgate and Cumbergate decided to develop this space to benefit both the city's retailers and their customers. Arcades had become popular during the nineteenth century for wealthy shoppers and the sumptuous Piccadilly Arcade in London, which had opened in 1909, was the model for the new Peterborough arcade. Architect Alan Ruddle devised a precinct that would create access between Westgate and the market while also providing an upmarket shopping experience for the fashionable interwar consumer.

The Westgate Arcade was designed in a Neo-Georgian style with elegant shopfronts that have retained their original moulded wooden window frames and recessed doorways. Natural light is provided through the roof where opaque glazing is supported by the upper-storey colonnade. The Westgate underwent extensive refurbishment in 2015. The arcade, which is one in a decreasing number of historic shopping precincts in Great Britain, was preserved in its original form. It now provides a sophisticated shopping area and leads into the adjacent Queensgate shopping centre.

Westgate Arcade has become a destination for the sophisticated shopper.

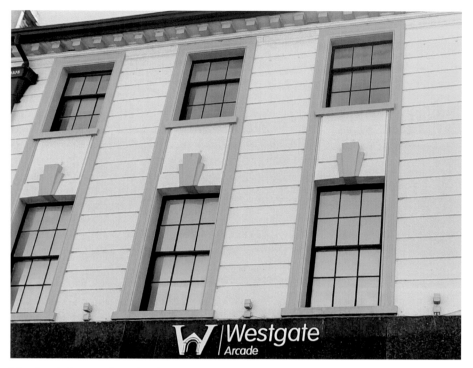

The façade has art deco details.

37. Park Substation (1932)

Peterborough and its population grew during the Victorian era and the need for
housing grew with it. The district around Central Park was one area of the city to
be developed in the mid-nineteenth century and long streets of prestigious houses
were built. Central Park itself opened in 1877 and became a popular recreational
destination for Peterborough residents. As people wanted to live near to such an
attractive open space, housing development continued to increase throughout
the Edwardian era and into the interwar years. A reliable power supply became
essential as the number of households grew and, in 1932, electricity substations
were placed at various locations within the district. These meant that the
demand for electricity never exceeded the supply and ensured that homes always
had power.

On Broadway is a fine example of how such a functional structure was designed
to complement its environment. The substation has a square footprint and
resembles a domestic dwelling. It is two storeys high and was built in Fletton brick
with a faux timber rendered panel just below the tiled roof. The roof contains
dormer windows for ventilation and the projecting V-shaped windows to the
front add decoration. Arched brickwork surrounds the entrance doors and the
fence and hedges to the front help to make the building blend into the street scene.

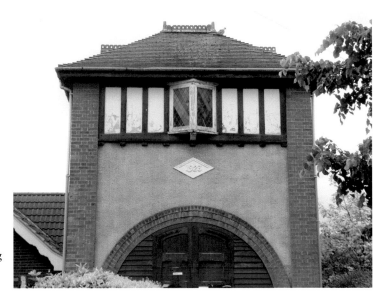

The electricity
substation
blends in with
the surrounding
interwar
housing.

38. Peterborough Town Hall (1933)

At the beginning of the twentieth century Peterborough was a small city that
still retained many of its old buildings. However, the city was beginning to grow
and an expanding population created a need for both social housing and urban
modernisation. The city council began to build council houses in the 1920s and
created a separate division to handle this new scheme. The council's headquarters
in the rooms of the Guildhall were too small for the additional department and
the decision was made to build a new Town Hall to provide more space. The
site chosen was in the centre of the city where rows of quaint but deteriorating
properties were demolished to allow for a complete modernisation of the area.
The Town Hall was the focal point of the new layout and architect Ernest Berry
Webber was commissioned to design it. Peterborough Town Hall was Berry
Webber's first major project and he created a modern but classically styled
building, which was completed in 1933.

 Peterborough Town Hall is the most commanding building on Bridge Street
with architecture that was influenced by Christopher Wren's design for the Chelsea
Hospital in London. The building has a very long façade and the portico over
the entrance is supported on a colonnade of Corinthian-style sandstone columns.
The Town Hall is brick-built with stone detailing and has a tiled mansard roof. A
lantern with copper cupola above the main door emphasises the civic importance
of the building, as do the four decorative plaques on the façade, which represent
lawfulness, education, biology and industry. These were designed by the architect.

 The foundation stone for Peterborough Town Hall was laid in 1929 and
the contract for the build was given to a local master builder, John Thompson
and Sons. However, they went bankrupt in the middle of the work because

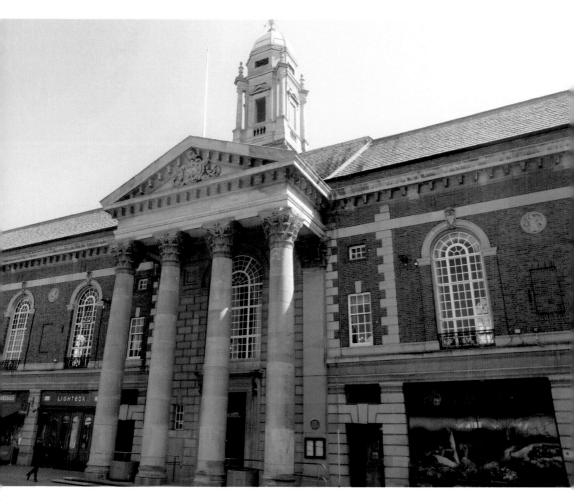

Above: Peterborough Town Hall modernised the city centre.

Left: Carved plaques add to the building's grandeur.

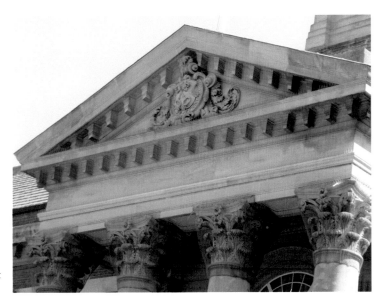

Decorative
capitals support
the portico.

they tendered a price that was too low to be financially viable. The project was delayed before being completed by Henry Willcock and Co. four years after it was launched.

There was a grand opening ceremony in October 1933. Afterwards, both the city and county councils moved in, and they continued to use the building as their offices for eighty-five years. In 2018 both councils moved to new premises at Fletton Quays. The Town Hall subsequently underwent refurbishment and is now occupied by the Cambridgeshire and Peterborough NHS Foundation Trust.

39. Town Bridge (1934)

From medieval times, Peterborough Town Bridge has been used as a fast and reliable way to cross the River Nene. The most recent bridge dates from 1934.

The wetlands around Peterborough have been inhabited for thousands of years and wooden causeways were built into the Fens as early as the Bronze Age to make travelling easier. However, a boat was necessary to take goods or livestock across the river until 1308, when Peterborough Abbey provided the first Town Bridge. This was a wooden structure and crafted by skilled medieval carpenters from sturdy timbers. Although it needed regular repairs, the bridge served the city well for over 500 years.

By the middle of the nineteenth century the bridge was getting an increasing amount of use and it was no longer possible to keep up with repairs. It became too dangerous for heavy vehicles to cross the old wooden structure, so a completely new iron bridge was constructed in 1872. It was designed by Sir John Fowler, a leading civil engineer who more usually worked on railway projects. Fowler

The Town Bridge crosses the River Nene.

had led the team who built the Forth Bridge and had been the chief engineer on the first underground railway in the world, the Metropolitan Railway in London. Although less ambitious than some of his previous projects, his design for Peterborough Town Bridge was well received by his peers. The three-span structure was wide enough to place footpaths on either side and it included gas lighting for safety.

Fowler's bridge was efficient but the roads leading to it were not. They were narrow and caused constant bottlenecks. Another issue with traffic flow was caused by a level crossing adjacent to the river. In 1929, permission was granted

The concrete structure has an uncomplicated art deco design.

for another Town Bridge to be built that was deep enough to cross both the Nene and the rail tracks. Funds were made available as part of a major redevelopment project, which went on to completely change the layout of Peterborough's streets and modernise the city centre. The new Town Bridge was designed by leading architects Gotch and Saunders and opened in 1934. It displays an art deco style and has simple arches and straight lines, which have great decorative effect. The bridge is made of reinforced concrete and crosses both the river and railway. It still serves as a main crossing over the River Nene and carries the A15 through the city.

4c. Peterborough Lido (1936)

Peterborough Lido stands on the embankment, close to the River Nene. It was built in 1936 and the architecture displays the combination of simplicity and flair that typifies the art deco style. As an outdoor pool that is still in regular use, it is a rare example of its genre.

The Lido was built as part of the major municipal redevelopments that occurred in Peterborough in the 1930s and replaced a public swimming space that had been

The Lido attracts large numbers of swimmers.

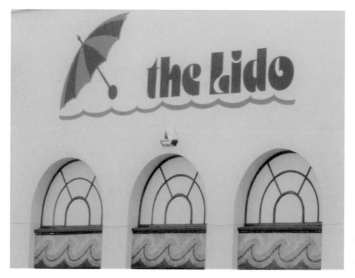

Art deco detailing
enhances the
building.

roped off in the river. The pool building and surrounding gardens were designed
by a group of local architects. It was built using local brick and painted in an
art deco colour scheme of white and green. The arcade around the bathing area
gives the Lido a classical appearance, while the grandstand on the upper level
has symmetrical flights of stairs that reflect the period in which it was built. The
colour of the pantiles is echoed in the oxidised copper roof of the clock tower and
there are many stylish art deco details.

 After opening to the public in 1936, the Lido was well received by Peterborough
residents. It was damaged in an air raid during the Second World War but soon
reopened and remained popular until the end of the twentieth century when a new
indoor pool was opened. Attendance fell dramatically, and when a fire in 1991
created a huge repair bill, the future of the Lido became uncertain. Peterborough
City Council considered demolition until a 'Save our Swimming Pool' campaign
was launched by the *Evening Telegraph* and public opinion was overwhelmingly
in support of a full restoration. The Lido now attracts swimmers from all over the
region and has been granted a Grade II listing by Historic England.

 The Lido is linked with one of Peterborough's more colourful characters, the
Daredevil Birdman, whose real name was Walter Cornelius. Walter was a lifeguard
and swimming instructor who worked at the Lido for many years and became
even better known for his annual attempt to fly across the River Nene. For this
major charity event, Walter dressed as a bird and tried to fly by flapping huge
wings attached to his arms. Although he never succeeded with the Nene crossing,
his escapades attracted large crowds and raised a lot of money. Walter was a
popular and philanthropic Peterborough figure, but he was not born in the city.
In the 1940s, Walter fled the communist regime in his home country of Latvia and
came to Peterborough after single-handedly rowing a 400-mile route across the
Baltic Sea. When he died in 1983, it was considered appropriate to commemorate

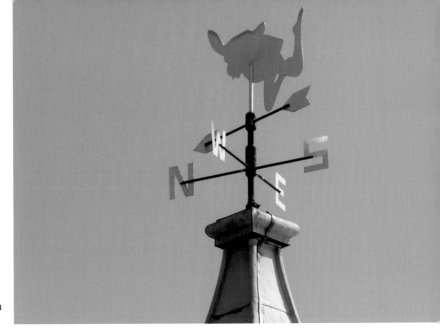

Walter Cornelius is memorialised in the weathervane.

him at the pool where he had spent so many years giving swimming lessons and acting as a lifeguard. Walter's many friends agreed that it would have appealed to his sense of humour to be depicted as the Daredevil Birdman. The weathervane on the Lido's clock tower was replaced with a silhouette of Walter during one of his attempts to fly across the river and is a fitting memorial to him.

41. Dog in a Doublet Lock and Sluice (1937)

The Dog in a Doublet sluice shares its name with a nearby waterside pub and is situated just outside Peterborough at Whittlesey. The pub was built in the seventeenth century during the first venture into Fen draining, while the sluice gate and its adjoining navigation lock were not constructed until 300 years later to finally protect the area from tidal flooding.

A lot of land was successfully reclaimed by draining the Fens in the seventeenth century, but this land and the city of Peterborough itself were still prone to flooding caused by the effect of sea tides on the River Nene. During the Fen drainage project, a deep straight channel had been dug between Peterborough and Wisbech to try to divert the course of the Nene but saltwater floods still came up it to regularly ruin arable farming land. It was only in 1930 that the Land Drainage Act meant government funding was finally available to protect the low-lying region from flooding. In a major feat of structural engineering, the Dog in a Doublet sluice gate was constructed in 1937 to dam the River Nene and prevent tidal surges affecting the river levels upstream from it. The metal barrier now protects the livelihoods of those who live in the Fens.

Next to the sluice is the Dog in a Doublet Lock, which is unusual as it has guillotine gates. These were designed to be hoisted up and down vertically to

Valuable farmland is protected from flooding by the massive sluice gate.

take up less room than traditional gates, which are pushed open by hand with a balance beam. The lock is 130 feet long and 20 feet wide and the water has a minimum depth of 6.5 feet. This makes the Dog in a Doublet Lock one of the largest in the country.

42. Embassy Theatre (1937)

The Embassy Theatre is on Broadway and is a fine example of art deco architecture. It was Peterborough's most luxurious setting for live performances during the 1930s and 1940s, and became a fashionable cinema in the 1950s. It has since been converted into separate units, which are used as hospitality venues.

The Embassy was designed by architect David Nye. He was a prolific cinema designer, but this was to be his only theatre project. When it opened in 1937, the building was the tallest in Peterborough, apart from the cathedral, and the subtle but striking art deco exterior was a focal point of the city's nightlife. The exterior was lit by neon lighting, and inside three sophisticated cocktail bars served refreshments all evening. The auditorium had velvet seats and deep pile carpets with underfloor heating, and the gold velvet stage curtain added a glamourous touch for the 1,400 patrons.

There were many famous actors and entertainers who performed at the Embassy, and in 1952 Laurel and Hardy were the headline act. Although they were approaching the end of their career, attendance numbers broke box office records and they played to a sold-out house every night. In 1953, the Embassy was converted into a cinema, but it still retained a space for live entertainment. The Beatles played at the Embassy twice. Their performance in 1962 got famously bad reviews, but a second in 1963, after they had started to become famous, was to an audience of screaming fans.

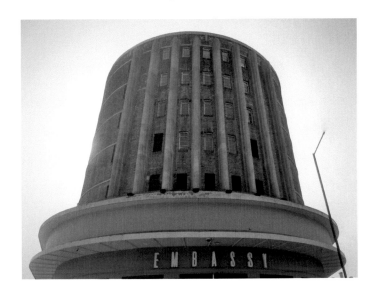

The Embassy
Theatre was
a stylish and
luxurious venue.

The cinema auditorium was as luxurious as the one for the theatre had been.
It had a massive Cinemascope screen with Stereoscopic sound and could house a
large audience. However, after the Embassy became part of the ABC cinema chain
it was converted into three smaller screens and no longer had facilities for live
performances. When a multiplex was opened in the 1980s, the older cinema lost

The building is still a major part of Peterborough nightlife.

so much custom it was forced to close and became a bingo hall. The building has since been sold several times. There is now a nightclub where the upper circle used to be, and the lower floor has been divided into two separate bars. The art deco building is still a commanding presence in the street scene and Peterborough Civic Society have recognised its architectural importance to the city with a blue plaque.

43. Baker Perkins Apprentice School (1954)

Baker Perkins have had a site in the Peterborough area for over a century. The engineering company opened the world's first purpose-built training school for apprentices on Westfield Road in 1954. Although the adjacent manufacturing plant was demolished in the early twenty-first century, the apprentice school remains and is a notable piece of architecture.

Baker Perkins began in 1920. Joseph Baker and Jacob Perkins had their own separate businesses until they collaborated on making automatic baking equipment for the military to use in the field during the First World War. Perkins already owned the Westwood Works in Peterborough and Baker moved from London after the two companies merged. As Baker Perkins expanded its range of food manufacturing machinery, the Westwood Works site also grew. New houses were built nearby to accommodate those who had moved up from London at the time of the merger, and employee facilities included a sports ground and social

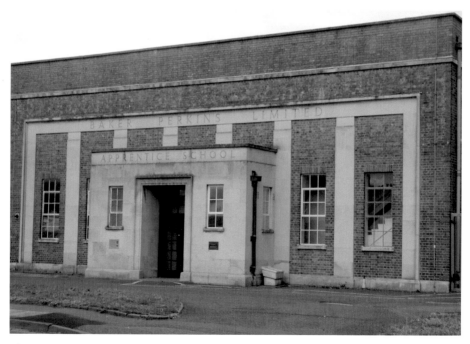

The Apprentice School has unusual modernist architecture.

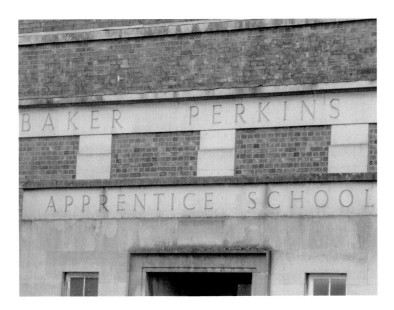

Baker Perkins
trained
thousands of
apprentices.

clubs. In the 1930s, the first apprentice training area was set up in an unused
administration office. After the Second World War, the need for skilled engineers
and technicians increased and Baker Perkins began training nearly 200 engineering
apprentices at a time in cramped conditions. Despite this, the company's training
methods soon became recognised as a national standard and government funding
was granted to build a new dedicated school for apprentices. The school went on
to train thousands of young men and women before it closed in 1991 after Baker
Perkins relocated to nearby Paston. The new plant continues to train apprentices
to exemplary standards.

Baker Perkins Apprentice School is of a post-war modernist design. The building
is influenced by classicism and is built using yellow bricks and natural-coloured
stone. The decorative pillars and plinth create the appearance of an ancient
Greek temple that is accentuated with the flat stone roof and entrance porch. The
apprentice school still retains its original steel-framed windows and much of the
interior woodwork and is waiting to be repurposed. The former Baker Perkins site
has been redeveloped and is now the location of HM Prison Peterborough.

44. St Jude's Church, Ravensthorpe (1969)

St Jude's Church is in the residential area of Ravensthorpe. This Peterborough
estate was built in the 1960s and was part of a government scheme to provide new
urban housing. The church provides architectural interest in a suburban setting.

In 1946, the British government began a programme of building new towns as a way
to provide accommodation for people who had lost their homes to bombing in the
Second World War. The scheme was so successful that another wave of development

St Jude's is a striking piece of architecture.

was launched in the 1960s to relieve housing shortages in densely populated areas. More new towns were built and specific towns and cities were designated for expansion. Peterborough was selected for development to ease demands on the London commuter belt and grew rapidly in the decades that followed.

Ravensthorpe was built close to the Westwood Airfield site. When the base was decommissioned in 1964, the land around it proved ideal for housing development. As the building of Ravensthorpe began, plans were also made to include a church to serve the new residents. St Jude's took fifteen years to complete, but the first part of the church opened in 1969 as a two-room building with an area for worship and another that could be used as a community hall. Subsequent enlargements included a chapel and a separate community hall, which would allow for the original building to be used solely for worship. The walled garden and tower were later additions and the church as it is seen today was finished in 1984.

The church is a contemporary piece of architecture. It was built with local materials in both red and yellow brick and details in the church wall are picked out in blue. The tower openings echo the shape of the church roof and the roofline of the tower sweeps upwards to emphasise the height of the cross that tops it. St Jude's is a striking building and is a landmark within Ravensthorpe.

Three colours of local brick are used to great effect.

45. Peterborough City Market (c. 1970)

Peterborough City Market was moved from Market Place, now called Cathedral Square, in the late 1960s and it is now housed in a purpose-built brick and steel building on Northminster. However, the history of the trading site dates back over a thousand years.

Peterborough Market has existed for hundreds of years.

The first market was held around the time of the Norman Conquest when the abbot of St Peter's Burgh Abbey allowed the people of the town to set up individual trading sites on church-owned land. At the beginning of the twelfth century, vast number of masons arrived with their families to work on the rebuild of the abbey and a large and permanent marketplace was needed to be able to provide goods to the increasing population. A site was laid out just outside the Great Gate with streets leading to it, and one of these ancient streets still exists today. Cumbergate meant the 'street of the wool combers', and was where those employed in making high-quality worsted cloth lived and had workshops producing woollen goods to sell in the market.

Peterborough also held large annual markets or fairs. One of these was the Bridge Fair, which was first held in the mid-fifteenth century. It attracted people to Peterborough from all over East Anglia where they could buy or sell all types of goods and produce. After 600 years, the Bridge Fair is still held every October, although it is now a traditional funfair. However, the ancient custom of holding a prayer service in the cathedral before it opens still endures.

Peterborough's markets have changed over the centuries. The cattle market was moved from Market Place when the land was needed for building. However, any buildings on the site stood lower than the surrounding ones because the blood-soaked ground of the butchery had to be dug out to a very deep level before any foundations could be laid. The cattle market moved to Northminster, where it was eventually replaced by the utilitarian structure of the current City Market. Although this general market has now also moved from the old market site, seasonal markets are held in Cathedral Square in its place.

Stalls still sell cloth and other goods.

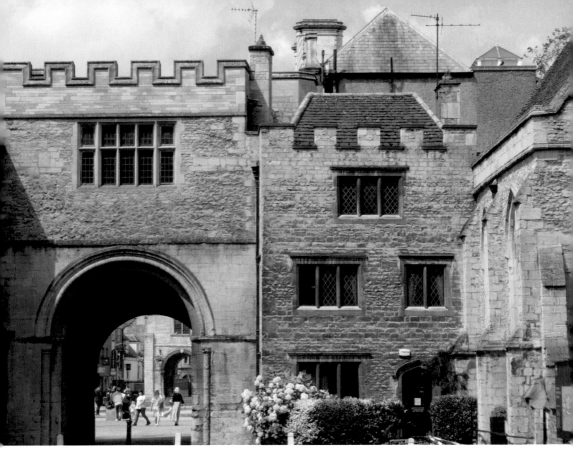

The market used to be just outside the Great Gate.

46. The Cresset (1978)

Bretton was built during the major urban expansion of Peterborough in the late 1960s. It was part of the third wave of developments brought about by the New Towns Act. The suburb, on the north-western side of Peterborough, is now home to approximately 13,000 people and The Cresset is the building at its centre. It is a multipurpose venue that incorporates one of Peterborough's major theatres.

The Cresset was designed to be the heart of the growing Bretton community. The name is derived from the medieval practice of keeping a beacon, or cresset, burning in the centre of towns and villages. This was an intrinsic part of community life at that time and it provided a place to meet for discussions about important local issues. The Cresset has a similar purpose for modern residents, acting as a gathering point.

The building has a utilitarian style and was built in concrete and brick. It was devised by local community groups and voluntary organisations and funded by the city council. The Cresset was officially opened by Elizabeth II in 1978. Alongside the theatre are shops, restaurants and sports facilities, and there is also a church, a youth club and a library. Twenty-first-century developments in Bretton

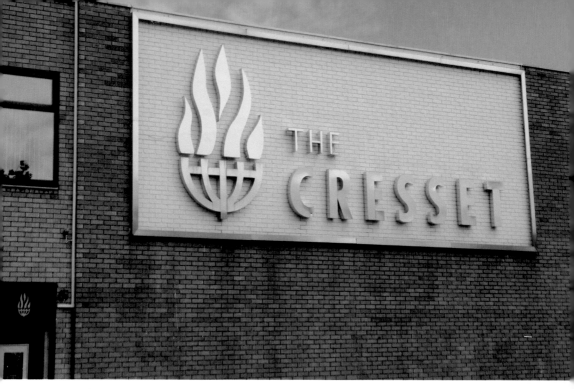

The Cresset is a modern multipurpose space in Bretton.

mean that The Cresset is now also in a tree-lined environment with many new parks and playing fields nearby.

47. Frank Perkins Bridge (1984)

The Frank Perkins Bridge crosses the Frank Perkins Parkway and was named after the Peterborough engineer who founded the Perkins Engines Group. The late twentieth-century structure is notable for its stylish concrete design and artistic details.

The steel and concrete bridge was erected during a major relief road project in the early 1980s. Sculptor Francis Gomila was commissioned to produce a decorative element for the bridge that would suit its urban location. He cast a series of relief designs into the concrete abutments that depict the components of a Perkins P3 engine. This reflects its position close to the Perkins Engines site and makes the bridge stand out within its environment.

The Frank Perkins Bridge is at one end of Fengate while the other heads towards the Flag Fen Archaeology Park. It was here, in 1982, that an important Bronze Age site was discovered by archaeologist Francis Pryor. He was surveying the Flag Fen Basin, which is the marshy area between dry land at Fengate and a natural island at Northey, when he came across a piece of timber in the waterlogged peat that had been preserved there for over 3,000 years. Extensive excavations revealed the

Right: Concrete details depict the parts of a Perkins engine.

Below: The bridge brings art to an urban environment.

scale of the find, which turned out to be part of a wooden causeway. Bronze Age settlers had driven thousands of sharp posts through wet mud into firmer ground below and then laid 60,000 timbers across them to create a path across the Fen to a place of religious importance. Archaeologists discovered numerous artefacts belonging to these early inhabitants of Peterborough in the surrounding area. By the Roman period, rising water levels had covered the structure and it became protected by the preservative qualities of the peat. Many of the finds are now on display in the museum.

Flag Fen offers an insight into an ancient culture.

48. Peterborough Volunteer Fire Station (1984)

The Peterborough Volunteer Fire Brigade began to serve the city in 1884, and their current fire station was built in 1984 to mark their centenary year. The brigade still consists of only voluntary staff and, as such, they are the last unpaid firefighting station in the country.

For centuries, Peterborough residents had to tackle fires on their own. The medieval city was crammed with timber-framed buildings, which meant that

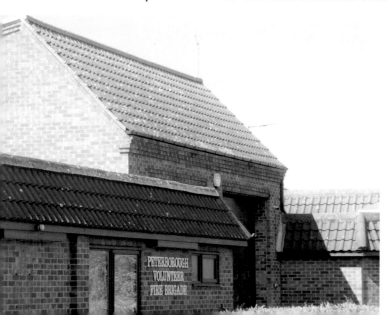

Trained volunteer firefighters have served Peterborough since the nineteenth century.

fires were a common occurrence. However, it was not until around 1600 that the feoffees first gave some assistance by providing eighteen leather buckets that the public could use to carry water to the site of a blaze. By the eighteenth century, insurance companies ran fire services for those who could afford the payments, but they were unreliable and when they were unable to put out a serious fire at the infirmary in the nineteenth century, a brigade of trained volunteers were recruited instead. The unpaid team soon made the service efficient, and the Peterborough Volunteer Fire Brigade are still serving the community today.

Their fire station is on Bourges Boulevard and is built in brick with a tile roof. Two fire engines are housed behind the red doors that dominate the building and the emblem of the brigade, with their motto 'Ready and Willing', is displayed on the front wall. The station is manned by a crew of six at all times and all the volunteers report to the county chief fire officer. Any volunteer has to go through the same rigorous recruitment and training programme as paid members of the Cambridgeshire and Peterborough Fire Authority, and they each train for two hours a week. Their great service to the community was recognised by Peterborough City Council when the whole brigade was honoured with the freedom of the city.

The brigade members are proud of their emblem.

49. Thomas Deacon Academy (2007)

The Thomas Deacon Academy is a modernist building in the Dogsthorpe area of Peterborough and opened to pupils in 2007. However, the school itself has a history that dates back to 1721.

It was 300 years ago that wealthy Peterborough landowner and philanthropist Thomas Deacon founded a charity to establish the original Thomas Deacon School in his name. Deacon's will stated that profits raised from his 'two freehold cottages and freehold farm, at all times and forever, be used for the setting up and endowing of a school in Peterborough' and this trust is still in existence. Under the name of the Thomas Deacon Foundation, it continues to support the modern academy in its new location.

The eighteenth-century school building was on Cowgate and, although it no longer stands, its position has been marked by the Peterborough Civic Society

Left: Thomas Deacon started supporting schools in the eighteenth century.

Below: The modernist design used environmentally aware building practices.

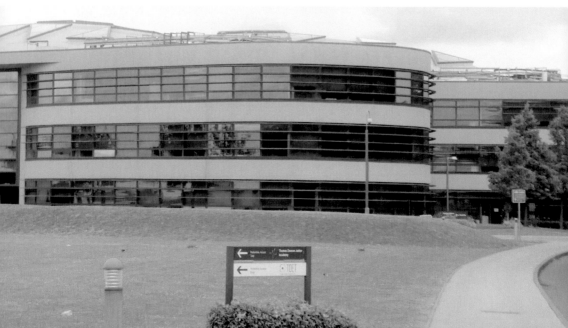

with a blue plaque. The Thomas Deacon School moved into larger premises on Crown Lane in the late nineteenth century and again in the 1960s, when the new Deacon Grammar School was built on Queens Gardens. Supported by the Thomas Deacon Foundation, the school continued to serve the area until the beginning of the twenty-first century when it was demolished to make way for the Thomas Deacon Academy. This award-winning and state-of-the-art site covers 43 acres and is the largest school campus in the country.

The £50 million project to construct the Thomas Deacon Academy began in 2005 to an architectural design by Foster and Partners, the company founded by Sir Norman Foster. Foster is a leading modernist architect and his company specialises in high-tech architecture, which follows an environmentally sensitive building technique. The roof canopy on the Thomas Deacon Academy is just one design feature that reduces the environmental impact of the structure. It provides the maximum amount of natural light to enter the building and the concrete soffits give shade to act as a natural cooling system.

The academy teaches over 2,000 pupils between the ages of eleven and nineteen and has a teaching structure similar to that of a university, where lectures and tutorials are given to supplement the syllabus. Classrooms and communal areas are all linked via footbridges and galleries to the central atrium and having this hub creates a community atmosphere within the school. There are excellent sports facilities and the Thomas Deacon Academy is also an integral part of the wider community as a separate sports hall, presentation theatre and hospitality area on the campus are available for public use.

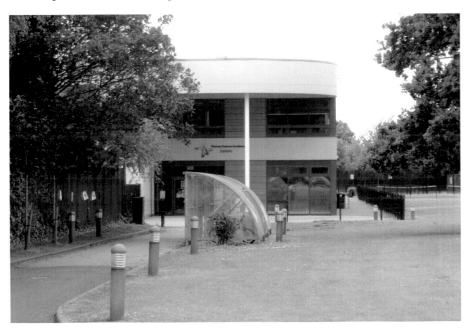

The campus includes large areas of grass and trees.

50. Peterborough City Hospital (2010)

Peterborough City Hospital is a bright and modern medical facility. It was the largest construction project undertaken in the city since the cathedral was built in the twelfth century, taking four years to build at a cost of over £300 million. The site was officially opened in 2010 by the Duke and Duchess of Cambridge.

The first hospital in Peterborough was established within the abbey over 1,000 years ago where an infirmary tended any monks who fell ill. Although a leper hospital was later founded on the site now occupied by the Volunteer Fire Station and St Thomas the Martyr Hospital provided shelter to the poor and needy, it was not until the mid-nineteenth century that a hospital in the modern sense opened in the city. Up to that time people had to tend the sick and injured themselves unless they could afford to employ the rudimentary services of a doctor. In 1856, a much-needed hospital was opened after the Fitzwilliam family purchased a large house in Priestgate and had it converted to provide proper health care and medical facilities for everyone in Peterborough.

The building soon became too small to meet the needs of the city, and in 1928 the newly built Memorial Hospital replaced it. The site was enlarged in the 1960s to

Peterborough City Hospital became the largest project since the cathedral.

The first public hospital was on Priestgate.

include maternity and accident and emergency services and at this time it was renamed the Peterborough District Hospital. In 1988, the Edith Cavell Hospital was built in the Westwood area and became a second major health facility serving the city. In the early twenty-first century and as part of the Greater Peterborough Health Investment Plan, the decision was made to merge with the District Hospital to create a single updated facility on the Edith Cavell site. This became Peterborough City Hospital.

The hospital was designed by Nightingale Associates. The company understands the value of natural views for patient wellbeing and situated wards on the higher levels of the building to allow patients to see the surrounding scenery. Where a view is not possible due to an inner-facing window, sedum roofs and planting within courtyards have been used to create an alternative green and natural atmosphere. The architects have set a new standard in building practices and have created an ecologically sensitive structure using environmentally friendly construction methods and materials. A high energy-efficiency rating has been achieved due to sensors that ensure lights are turned off when not in use. Peterborough City Hospital has over 600 beds and offers a wide range of specialist care with exceptional facilities and emphasis on patient wellbeing.

Patient wellbeing is at the forefront of care.

Bibliography

Books

Mackreth, D., *Peterborough History and Guide* (Stroud: Alan Sutton Publishing, 1994)

Skinner, J. (ed.), *Peterborough: A Miscellany* (Salisbury: Identity Books, 2012)

Websites

'A History of Peterborough', localhistories.org (2021; accessed 3 January 2022)

Cambridgeshire Fire & Rescue Service, cambsfire.gov.uk (accessed 29 January 2022)

'Listed Buildings in Central Ward, Peterborough', britishlistedbuildings.co.uk (accessed 10 November 2022)

'Local List of Heritage Assets in Peterborough', peterborough.gov.uk (December 2020; accessed 12 November 2021)

'Norman Cross Prison', peterborougharchaeology.org (accessed 13 February 2022) Peterborough Civic Society, peterboroughcivicsociety.org.uk (accessed 10 November 2021)

'Peterborough: From Past to Present, and Beyond', themomentmagazine.com (accessed 20 November 2021)

Peterborough Local History Society, peterboroughlocalhistorysociety.co.uk (accessed 10 December 2021)

St Margaret's Church, stmargaretschurch-fletton.co.uk (accessed 23 February 2022)